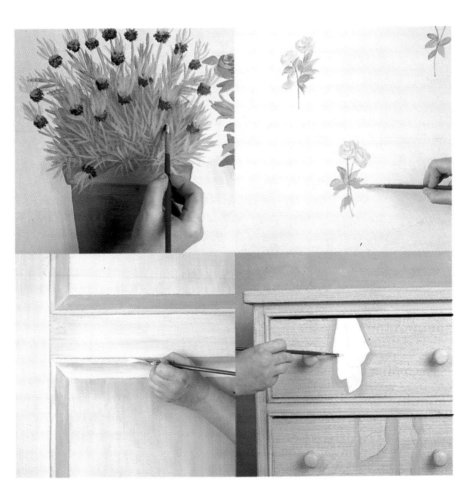

TROMPE L'OEIL

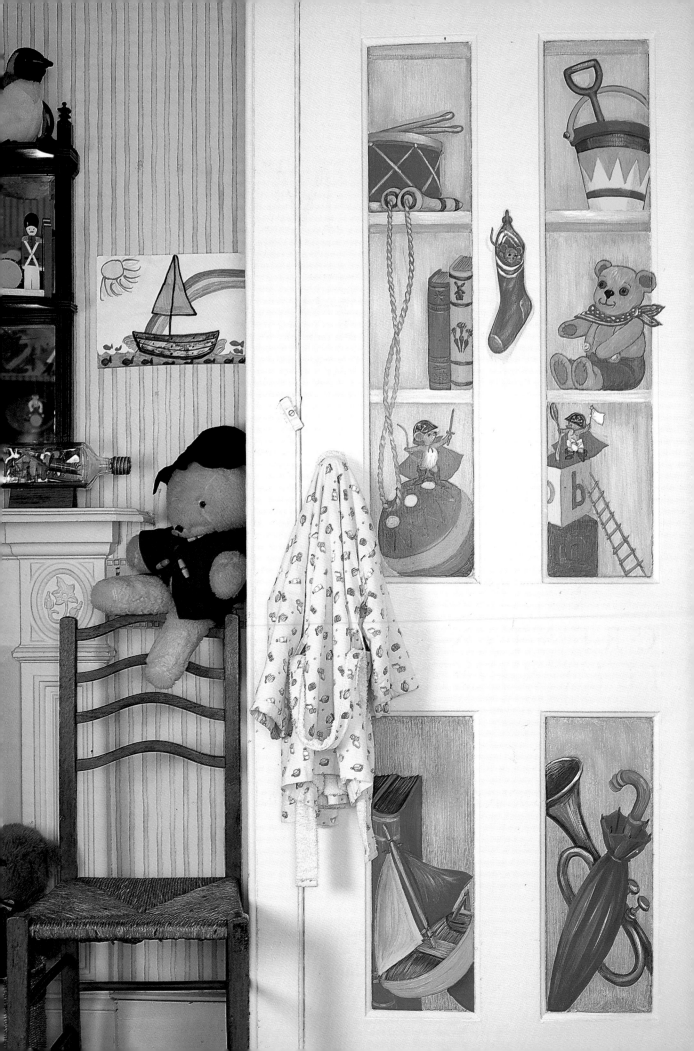

TROMPE L'OEIL

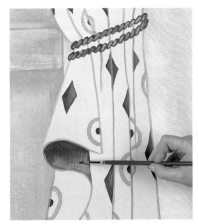
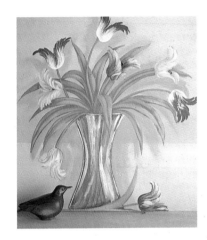

CREATING DECORATIVE ILLUSIONS WITH PAINT

ROBERTA GORDON-SMITH

David & Charles

For Georgina

A DAVID & CHARLES BOOK

First published in the UK in 1997
Reprinted 1998 (three times)
Reprinted 1999 (twice)
First published in paperback 2001
Reprinted 2003

Distributed in North America
by F&W Publications, Inc.
4700 East Galbraith Road
Cincinnati, OH 45236
1-800-289-0963

A catalogue record for this book is available from the British Library.

ISBN 0 7153 1257 X (paperback)

Edited by Alison Wormleighton
Photography by Shona Wood

Printed in Italy by G. Canale & C. S.p.A.
for David & Charles
Brunel House Newton Abbot Devon

Visit our website at www.davidandcharles.co.uk

David & Charles books are available from all good bookshops;
alternatively you can contact our Orderline on (0)1626 334555 or write to us at
FREEPOST EX2110, David & Charles Direct, Newton Abbot, TQ12 4ZZ
(no stamp required UK mainland).

CONTENTS

Introduction 6
Materials, Equipment and Basic Techniques 8

TECHNIQUES 14

COLOURWASH EFFECTS 16

FREEHAND FLOWERS AND FOLIAGE 34

FAUX FABRIC AND TRIMMINGS 48

ADDING PERSPECTIVE 58

THE PROJECTS 72

INSPIRATIONS 120

INTRODUCTION

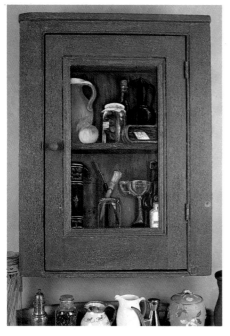

Trompe l'oeil is a French expression meaning 'trick the eye'. The technique involves creating the illusion of three dimensions to suggest that an image is real. It was used by the ancient Greeks and Romans, during the Early Renaissance, and during the Neoclassical revivals of the eighteenth, nineteenth and twentieth centuries. The early frescoes in churches illustrate illusion on the grand scale. In addition, trompe l'oeil is found in murals and paintings, in stately homes and public places, as well as in a variety of smaller-scale situations. Architectural elements (columns, pilasters, plinths, arches) and classical images (urns, leaf emblems, busts) have often been used, along with devices such as false perspective, to create a realistic effect. Surfaces that are painted to look like stone – known as faux stonework ('faux' meaning 'false' or 'fake') – are an important means of creating these effects. Similarly, a technique known as *grisaille* – painting in shades of grey to imitate low-relief sculptured friezes and panels – has been popular for over three centuries.

Yet trompe l'oeil does not have to involve a large mural or a Grand Illusion. Often, 'less is best' with this technique. You may manage to create something that people have to touch to decide if it is real or not, or it may simply be an attractive decorative effect or witty visual joke. But whatever you produce, if you follow the instructions and tips in this book, you are bound to create trompe l'oeil effects to be proud of.

You can be quite ambitious with projects based on these techniques, but it's important to start with something you feel you can confidently complete. Painting onto a plaque, a door or a small area of wall is best for a first project. The pediment on page 24 is ideal: although it has the look of a complex mural, it is in fact very simple when broken down into stages. After tackling a few small projects, you will be able to contemplate larger pieces and even entire rooms.

Dramatic illusions can often be achieved with something simple, such as a terracotta pot and some foliage painted at the back of a work surface. Small details like this can be effective anywhere in the house, though the subject matter does need to relate to the room. More ambitious projects are also possible for every room of the house. The entrance hall, for example, can be made to appear larger with a mural. Alternatively, a few faux pots and a column can open out a narrow space. A faux window or niche could add interest to a narrow hallway.

Bathrooms are another area where you can be quite ambitious, particularly guest cloakrooms and second bathrooms, since they are not usually very big. Often in these rooms there are no

windows, therefore giving the illusion of more space or creating a window with a 'view' can be just what is needed. In a small cloakroom under the stairs, with irregular walls and a sloping ceiling, covering the walls in faux drapes of fabric can work very well.

Bedrooms can be themed with strong ideas and images. Moody sky ceilings are especially effective here. Fitted wardrobes with pastoral views mistily painted in the background and foreground details of stonework and pots of flowers and foliage, dramatically framed with draped faux fabric, add another dimension to the bedroom.

In kitchens, trompe l'oeil objects on shelves can be painted on the panels of kitchen unit doors. Personal objects like trophies or favourite vases can be used as reference for these. Extend the visual joke and increase the ambiguity of the composition by placing the real object nearby. As well as your own memorabilia, you can obtain inspiration from a variety of sources, ranging from interiors books and magazines to soft-furnishing tassels and trimmings.

If you are lucky enough to have a designated dining room, there is plenty of scope for dramatic

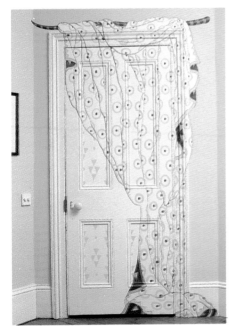

effects. Because the main furniture is usually in the centre of the room, this leaves a lot of floor-to-ceiling wall space for trompe l'oeil. Faux panelling and stonework, with landscape details and columns, will set the atmosphere, and skies can be painted to look dramatic in candlelight. For sitting rooms, a background paint effect like faux panelling works very well, as it will enhance pictures hung against it. Chimneyboards and firescreens are good sites for trompe l'oeil, perhaps using some painted book spines with personalized titles.

The beauty of trompe l'oeil is that it can be used to add character to a room that is lacking it, to reinforce or augment the ambience of the home, and to unify the various decorative elements of a room. It is possible to spend just a few hours and create a dramatic improvement.

Subtlety is important. The application of paint to walls, doors, furniture and objects does require a feel for texture, tone and composition, but by building up your skills with this book and using the techniques subtly, you will soon have acquired a feeling for the artistic elements. Many of the techniques require practice, so don't try any of them without first having practised on stiff cardboard. All of the techniques and projects have been broken down so that the effects can be done in stages, adding details over a period of time as you increase your skills. We demonstrate the techniques on a mural, which builds up as the book progresses, but you can obviously use the same techniques in completely different situations, to suit your own home and tastes.

In our projects, we have used thin washes of muted colour. Water-based paints are safe and easy to handle, and these colourwashes produce a pleasingly uneven finish and a soft, faded look that will blend in with the room. Whichever techniques you prefer, from faux stone to Italian distressed walls, trompe l'oeil will add a special ambience to your home.

MATERIALS, EQUIPMENT AND BASIC TECHNIQUES

People often assume that you need a lot of expensive materials and equipment to do trompe l'oeil painting, but this is not the case.

PAINTS AND WATERCOLOUR PENCILS

I only ever use water-based paints, as I find that oil-based paints take a long time to dry, cannot be disposed of easily and are generally not user-friendly, being toxic and smelly. Vinyl matt emulsion (latex velvet) and acrylic paints are therefore used throughout this book. Acrylics and emulsions can be mixed, and many of the projects call for emulsions for background effects, and acrylics for small amounts of colour. Test-pots of emulsion are also useful when you only need a little bit of a colour.

For a palette, you can simply use an old plate or tin lid. To store paint overnight on the palette, cover it with clingfilm (plastic wrap). To store it for a few days, cover it with water, and then drain it when you want to use it again.

Watercolour pencils are perfect for sketching designs on walls and furniture, as they can be completely washed off if you decide to alter anything. Most art shops sell these individually as well as in sets, so tan, grey, rust and green should cover your initial requirements.

PAINT COLOURS

To begin experimenting with the effects in this book, all you need are a handful of colours. And you will find that the other colours used tend to duplicate each other, so you will not need to invest in lots of new colours every time you undertake a new project.

Among the emulsion colours that are used repeatedly throughout this book are dark green, terracotta and cream. The dark green and terracotta can be mixed to make brown for shadows, stems and branches. The terracotta can be shaded with the brown, or lighter tones created by adding cream. The light green is used for foliage, with the highlights created by adding cream and the shadows by adding dark green.

Medium and dark beige tones are used for creating stone walls, pillars and pediments, and faux panelling, as well as old leather books and cork bottle stoppers.

Lavender is used for the lavender herb and for wisteria, while rust red emulsion produces flower heads, books and toys. Yellow gold is useful for flower heads and toys, while deep blue can be mixed with red for dark tones in lavender heads and bunches of black grapes.

SCUMBLE GLAZES AND VARNISHES

Acrylic scumble glaze (glazing liquid) is now widely available along with acrylic varnishes. To colour scumble glaze, mix it with emulsion in a ratio of three parts scumble to one part paint, to use as a background finish for trompe l'oeil. Or simply mix it with acrylic on the palette to create a glaze of shadow on the wall behind objects when you are working on wallpaper or an already painted surface.

To go with the water-based paints, use water-thinnable varnishes to protect the surfaces. I only ever use a dead flat matt acrylic varnish, even for floors (on which I use two or three coats), but if a floor will get heavy wear, you may prefer to use polyurethane varnish.

MASKING TAPE

Low-tack masking tape such as Easymask is used for masking edges when painting faux stone and panelling. It is also handy for protecting light switches and the tops of skirting boards (baseboards) when you are colourwashing. Although expensive, low-tack tape is preferable to conventional masking tape because it is less likely to pull off paint when it is removed, and it can be re-used a number of times. It is now widely available, but if you can't find the low-tack variety, conventional tape can be made less tacky by dabbing the adhesive side on fabric prior to use.

BRUSHES

Only four brushes are needed for the trompe l'oeil techniques shown in this book. A 5cm (2in) wide *decorator's brush* is used for painting some of the backgrounds. I actually prefer to use a varnishing brush for this, as it is not quite so thick as a decorator's brush and so is easier to control. But after a brush has been used for varnishing, it should not be used for painting, so to avoid any confusion I have referred to the brush for painting as a decorator's brush. If you want to varnish any of your projects, you will need a separate 5cm (2in) wide *varnishing brush*.

The second brush you will need is a *fitch*, which is a small decorator's brush. Fitches come in different sizes and shapes, but I like the flat, angled type, which gives good control for cutting in with the paint around the edges. A 2.5cm (1in) wide fitch is perfect for shading smaller areas and for blending colours together on backgrounds.

The other two brushes are *artist's brushes*, sizes 5 and 8. These will give you a good range of brushstroke sizes, and the no. 5 is small enough for fine detail. You may prefer to use a no. 7 and a no. 4, but do not go any smaller than this. Synthetic brushes are fine, as they keep their shape well.

CARE OF BRUSHES

All the products used for the paint effects shown in this book are water-based, and water is therefore used for cleaning all equipment. Emulsion paint dries quickly on the brush, so soak it in warm water and washing-up liquid after use. Do not leave brushes in paint or water overnight.

Use a stiff pan-cleaning brush or nail scrubber to scrub and comb the emulsion out of the decorator's brush and fitch, then lay them on newspaper or hang them up to dry. Rinse the artist's brushes well with water, and shape the bristles to a point. Leave them with the bristle ends upwards in a glass jar.

Rinse the scrim (mutton cloth) used for colourwashing and leave it in water for use the next day. Old pieces can be dampened and used to cover pots of colourwash in order to prevent a skin from forming.

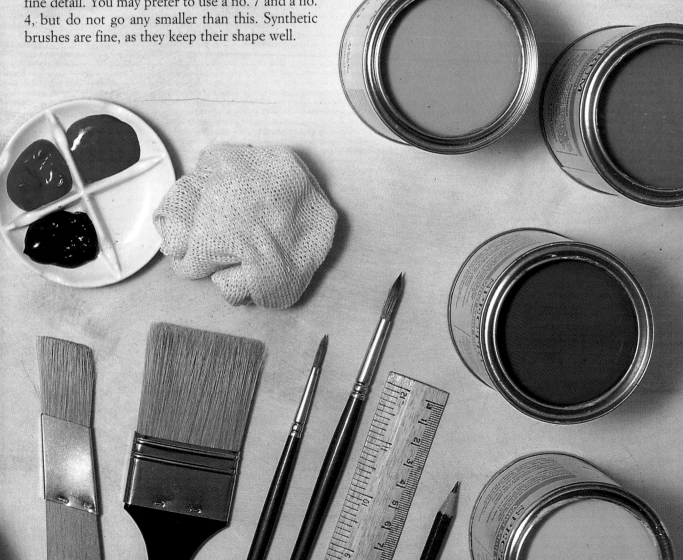

OTHER MATERIALS AND EQUIPMENT
If you are preparing walls, you will need an *emulsion roller and tray* and a *radiator roller (long-reach roller)*, which is a small, soft roller that helps you get the paint into the corners and around light switches and windows. For applying colourwashes you will need some *scrim (mutton cloth)*.

Other materials you will need are sandpaper, lining paper (to work out large designs), tracing paper and pencils. You may also need gold size and metal leaf if you want to experiment with some metallic finishes.

The only other equipment you will need is a large spirit level (carpenter's level), metal metre ruler (yardstick), tape measure, large and small white plastic paint kettles with lids, glass jars of various sizes to store paint in and to use as water containers, and a plastic sheet or dust sheet.

Preparation

Most of the paint effects in this book are painted onto a background of diluted vinyl matt emulsion (latex velvet) paint known as a wash or a colourwash. This will require the following preparation beforehand.

WALLS
Sand down and fill any cracks as necessary. Use a paint roller to apply white vinyl matt emulsion (latex velvet) so that the roller leaves a stipple effect in the paint. Do not thin the paint much when you apply it, as that would prevent the lightly stippled texture from developing on the surface as the paint dries. This stipple effect is important, because when the base coat is covered with the wash, the stipple will produce the right patina on the surface.

Similarly, don't be tempted to use ordinary emulsion (flat latex) for this; it just absorbs the colours of the specialist painting instead of allowing them to be blended on the surface.

It is essential to get the roller into the corners. A radiator roller can be used to reach into smaller areas. Be careful not to leave any brush marks or let the roller 'slip', creating a flat surface.

WOOD AND METAL
For woodwork and all furniture, even if it has been painted before, sand down and fill as necessary, then paint the surface with up to three coats of acrylic undercoat primer, using a decorator's brush. Do not thin the paint.

For metal items such as a table for the garden, an old metal bucket or a filing cabinet, sand down with medium-grade sandpaper (for bare metal) or wet-and-dry sandpaper (for previously painted metal). Now apply a coat of metal primer. (This is spirit-based, so you will need to clean the brush with turpentine afterwards.) Allow the metal primer to dry and then apply one or two coats of acrylic undercoat primer. Leave this to dry for 24 hours before proceeding with the colourwash.

Background finishes

In the projects included in this book, various paint effects are used as backgrounds and to decorate the surrounding areas – these are introduced below.

DRAGGING
1 Prepare the wood with acrylic undercoat primer or the walls with vinyl matt emulsion, as explained above; allow to dry. Pick a vinyl matt emulsion slightly darker than the one you want, and dilute it with water in the ratio of two parts paint to one part water. Or add acrylic scumble glaze (glazing liquid) to the emulsion in the ratio of three parts scumble to one part paint. (For larger areas, this is advisable, because the glaze takes longer to dry and so gives you more time to work.)

2 Apply the thinned paint or glaze to the surface following the grain, then draw a clean decorator's brush steadily across the glaze before it has dried, leaving an even 'grain' effect. Wipe off the excess paint at each end. You can continue stroking the brush along the glaze for a lighter effect, but do not overwork it.

Right: Dark, medium and light tones of vinyl matt emulsion (latex velvet) have been used to create a distressed finish (see page 12) on this wardrobe and chair. Even the curtains and upholstery have been painted.

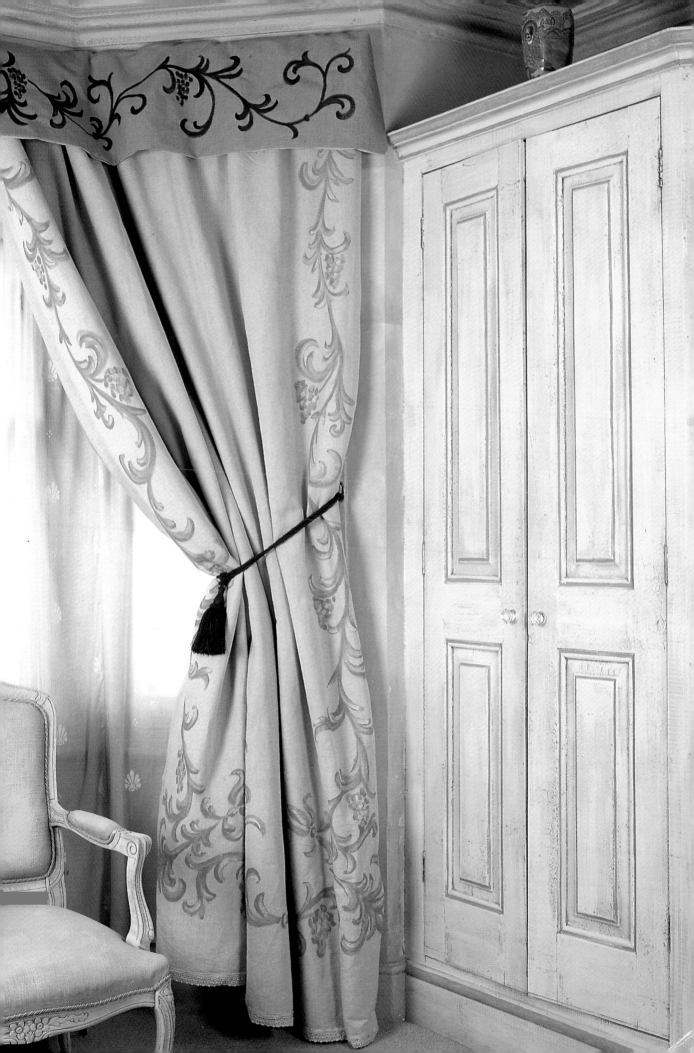

DISTRESSED FINISH

1 For this finish, which is used only on wood, you need dark, medium and light vinyl matt emulsions (latex velvets). Prepare the wood with acrylic undercoat primer, then apply the dark emulsion as a solid base coat using a 5cm (2in) decorator's brush. Allow it to dry.

2 Without adding water, load a dry brush with the medium-toned emulsion, taking off the excess on a palette or lid. Slowly stroke the paint on, following the grain of the wood. Allow the base colour to show through, and 'scuff' the paint as you work. Clean and dry the brush, and allow the paint to dry.

3 Load the brush in the same way with the light-toned emulsion, and scuff it on in the same way. If desired, protect with one or two coats of varnish.

COLOURWASHING

Colourwashing is a subtle, softly textured effect, which can be applied to walls, wood or metal. It is created by painting a 'wash' of water-based paint over a pale base. The finely stippled texture is achieved by using a roller for the base coat. Once it is dry, the colourwash is rubbed on with scrim (mutton cloth).

The base coat is most often white, but you can experiment with a coloured base coat as long as the colour is much paler than the wash you apply over the top. Another variation is to apply a second wash, in a deeper tone, over the first. But whether you are using this two-tone colourwash, or a single-tone colourwash over a coloured base coat, the different shades should be related – for example, rust and raw umber could be used with an ochre or yellow base coat.

To soften very deep colourwashes, you can colourwash a second time over the whole area, when the first wash is dry. Do this with a very watery white (10 parts water to 1 part white paint) or with a very pale mix of the colourwash.

For a room about 3.7 x 4.3m (12 x 14ft), you will need approximately one to two litres (quarts) of vinyl matt emulsion (latex velvet), which will be thinned down with water. The more water you use, the thinner and more translucent the colourwash will be and the softer the overall effect.

Before starting, try out your colours on stiff cardboard. Then, if possible, begin with a small alcove wall to help you 'warm up' for the bigger areas. When you are working on a large wall, it's not essential to complete the whole expanse; just remember to 'soften out' the edges by making them slightly lighter, to prevent visible overlaps.

To store a colourwash mixture overnight, cover it with either the lid of the paint kettle, damp scrim (mutton cloth) or clingfilm (plastic wrap). Always stir well before reusing it. If it has been standing for two to three days, a curly whisk is useful for agitating the mixture.

Emulsion (latex) paint dries quite quickly and has a tough finish, so most areas will need no extra protection. In a hallway, kitchen, bathroom or nursery, however, you can protect the effect with a coat of water-based varnish. A flat (matt) finish is recommended, but if you want a lacquered effect, satin or even gloss can be used. Remember that any shine will accentuate faults (though sometimes this actually adds to the effect).

YOU WILL NEED

White base coat – either vinyl matt emulsion (latex velvet) (for walls) or acrylic undercoat primer (for wood or metal)

Vinyl matt emulsion in medium tone (such as medium beige or medium green)

Vinyl matt emulsion in dark tone (such as dark beige or dark green), for two-tone colourwash only

Low-tack masking tape

Roller and paint tray (for walls) or decorator's brush (for wood or metal)

Paint kettles: 1 (for single-tone colourwash) or 2 (for two-tone colourwash)

Scrim (mutton cloth)

Fitch brush

SINGLE-TONE COLOURWASH

1 Apply the white base coat to the entire surface with a roller or brush (see page 10). Leave to dry.

2 In a paint kettle, mix the beige emulsion (latex) with water in the proportion of about 5 parts paint to 1 part water, adding the water gradually until it is the consistency of runny custard.

3 Hold the scrim (mutton cloth) in one hand to form a smooth pad. Be prepared to get paint on your hands – you can wear rubber gloves if necessary. Dip the cloth into the diluted paint and take up quite a lot. Squeeze it out over the paint kettle and then dip it lightly back into the wash. The cloth should be saturated with the colour but not actually dripping.

4 With an oval rubbing motion, apply the paint to the surface, working over an area of about 1 square metre (1 square yard) at a time. Work the paint into all the stipples thoroughly. Soften the edges by applying the paint more lightly. As the paint dries, go back over it with the same oval rubbing motion, to burnish the surface.

5 A fitch brush is better than the scrim (mutton cloth) to work the colour into corners. Use it with a scrubbing action to get the same texture, then soften the edges with the scrim. Protect areas you are not colourwashing using low-tack masking tape if you wish.

6 Before the paint has dried completely, go back and rub over the edges of each square-metre (square-yard) area to blend them together. You can also fill in any areas that you feel need more colour, but remember not to make it too even. Continue in this way until the surface is finished.

TWO-TONE COLOURWASH

1 Apply the white base coat to the entire surface with a roller or brush (see page 10). Leave to dry.

2 In a paint kettle, mix the medium-toned emulsion (latex) with water in the proportion of about 1 part water to 5 parts paint. In a second paint kettle, thin the darker emulsion with water in the same way.

3 Apply the diluted medium-toned paint as for a single-tone colourwash, steps 3 and 4, leaving the edges jagged. The edges have to be jagged so that solid patches will not emerge when the second colour is applied. Once you have covered about 3

square metres (3 square yards), stop and soften out the edges to make them lighter. (This area is larger than for a single-tone colourwash because there will have to be enough space for the relatively small patches of the second colour to be worked into this colour when they are applied.)

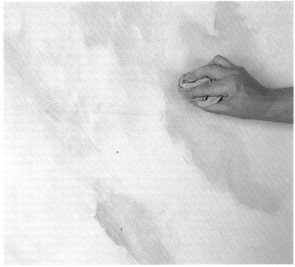

4 Use the scrim (mutton cloth) to apply patches of the darker colourwash onto the medium-toned wash, softening the edges by making them lighter and blending them into the first colour. Repeat the process over the next area.

5 Continue until the whole surface is finished, using the fitch brush to get the wash into the corners as before. Finally, stand back and check the effect, then soften or strengthen the finish where necessary before it has dried completely.

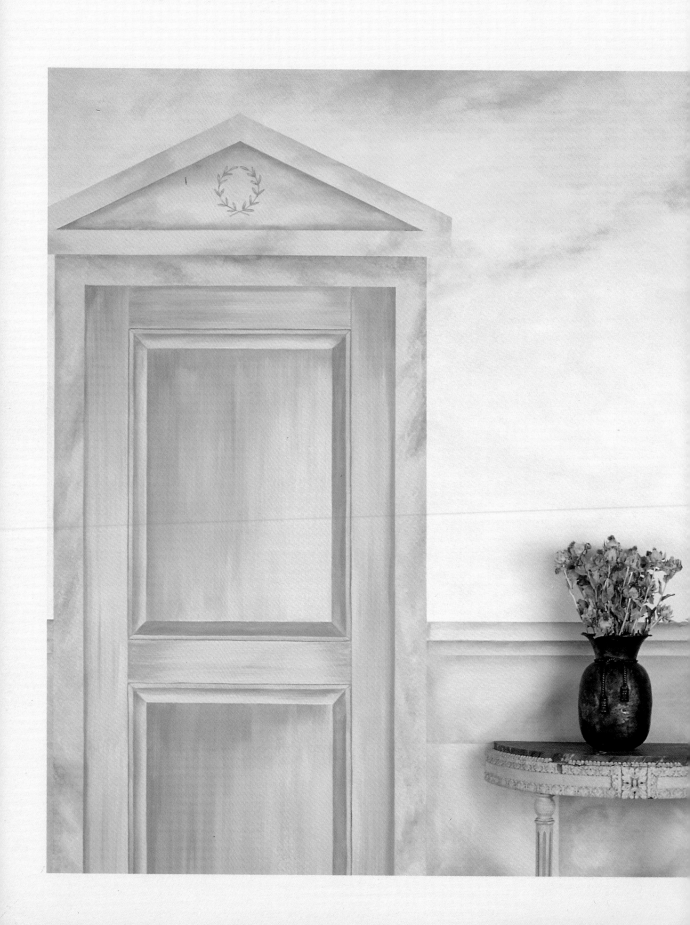

TECHNIQUES

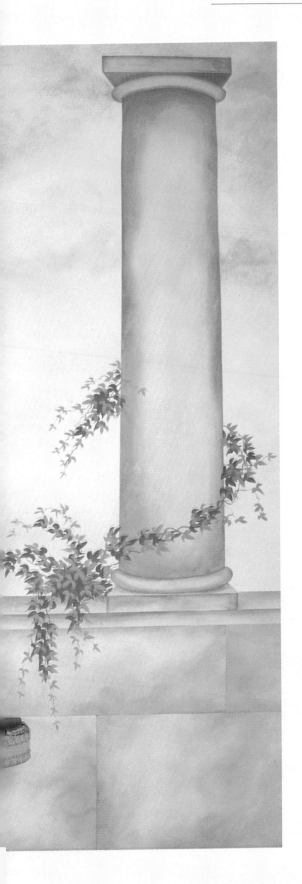

Before attempting any of the projects in the second part of this book, you will need to learn the basic techniques of trompe l'oeil, which are explained in this first part. They are divided into four sections. The first covers stonework and architectural effects, plus a simple sky-effect ceiling; the second deals with flowers and foliage; the third shows you how to paint fabric and trimmings; and the fourth covers shelves and ornaments, and how to add perspective to your work.

Even the most complex projects can be broken down into simple stages involving these techniques. To demonstrate this, the techniques in these four sections are used to create murals, which you can see building up as each technique is added to it. The complete mural appears at the beginning of the section. For example, the one for the first section, which is shown here, comprises faux stonework, a pillar, a stone ledge, a pediment, a sky background and a panelled door – all of which are covered in separate step-by-step sequences. After learning each of the techniques covered in a section, you could paint a mural like this if you wished. Alternatively, you can use those techniques, along with the ones from the other sections, in the projects that appear in the second part of the book – or even create your own trompe l'oeil designs.

COLOURWASH
EFFECTS

Colourwashes or washes (which are diluted less than colourwashes) are used as a background for most of the trompe l'oeil effects covered in this book, as they create effects similar to the faded, weathered stucco walls found around the Mediterranean and in other hot countries. Colourwash is also a good technique for creating a sky effect.

In addition to trompe l'oeil backdrops, colourwashed walls make attractive backgrounds for hand-painted details such as small fleur-de-lys, flower or star motifs. A hand-painted border, perhaps echoing a floral fabric used elsewhere in the room, looks good against colourwashing too.

The aim of colourwashing is an uneven finish, and the colour can be built up until you achieve the desired effect. It is a good idea to work on just one wall at a time initially. That way you can go back and adjust the colourwash if there are any areas that look too strong or too light.

Pale pastels and soft, muted shades tend to be the most successful. If you'd like a large sample to look at before you start, colourwash a large piece of card that you have previously rollered as you would the walls.

Colourwash can be applied quite thinly and left, to look like a wash of colour. Alternatively, for the thicker, drier look of old stucco, let the colour dry a little then 'polish' the wall with a cloth. The best way to find the effect you want is to experiment on a small wall or large piece of card.

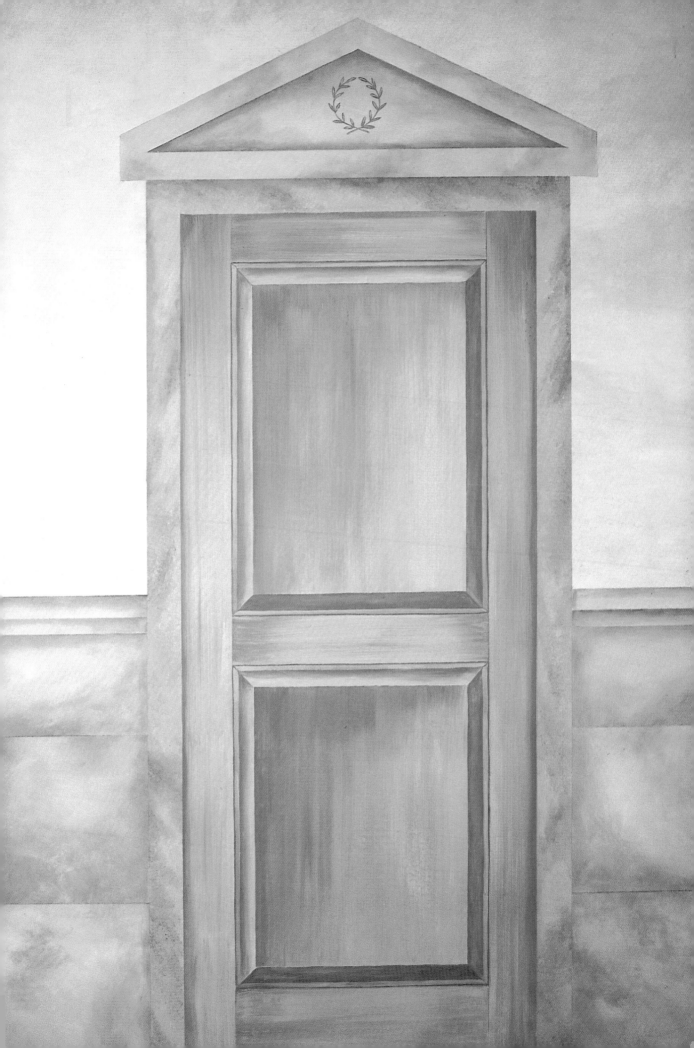

Faux Stonework

A faux stonework effect is created by painting individual 'blocks' using the colourwash technique and shading the edges of each block a little to define them.

There are lots of effective ways in which you can use this technique. In a bedroom the walls can be painted with faux stonework to create a lovely background for the bedroom furnishings. The skirting boards (baseboards) and door surrounds could then perhaps be painted to match the walls. To do this, brush on an acrylic primer undercoat, then dip a 5cm (2in) decorator's brush at random into the colourwashes used for the walls and drag it along the woodwork for about 1 metre (1 yard) at a time, blending the colours. With scrim (mutton cloth), softly wipe off some of the wash to soften the edges, before painting the next length.

If there is a cornice (crown molding), brush on an undercoat of vinyl matt emulsion (latex velvet), then apply the paints undiluted with the 5cm (2in) decorator's brush, using a stippling, dabbing action. Soften as for the woodwork (see above).

A faux stone effect can also look good beneath a chair rail, combined with a soft colourwash above the rail. Another idea is to give a bathroom the look of a Roman ruin by colourwashing the ceiling and upper walls in a soft sky blue (see page 28), and using the faux stone on the lower walls, then adding a pillar (see page 20) or an urn with some foliage draped over the edges.

The technique shown here is an effective way of simulating the texture of stone. Three shades of diluted beige vinyl matt emulsion (latex velvet) are used over a white vinyl matt emulsion base coat to create the look of dirty or worn patches on stone. The more varied the shading of each block, the more realistic the final effect. The shading defines the edges of the slabs, so cement or grout lines between the blocks are not necessary (and can, in fact, look overdone). It's a good idea to try out the shading technique on stiff card before tackling the wall itself.

Prior to painting, the area is carefully measured and the outlines of the blocks pencilled in lightly, then masking tape is run along these guidelines. The slabs should be a size that will fit the area exactly, but to look realistic they will need to be approximately 50cm (20in) high by about 70cm (27in) wide. The width can vary by about 5cm (2in) without being noticeable.

YOU WILL NEED
Base coat in white
Vinyl matt emulsion (latex velvet) in cream, medium beige and dark beige
Roller and paint tray
Retractable tape measure
Metre ruler (yardstick)
Pencil, such as a watercolour pencil
Low-tack masking tape
3 paint kettles
Scrim (mutton cloth)

1 Apply a white base coat over the entire surface with a roller (see page 10), to give a stippled finish. Measure the wall and work out the size of the stone slabs. Using the metre ruler (yardstick) and pencil, lightly draw the horizontal lines then draw the staggered vertical lines.

2 Apply tape around the outside of the slab you are starting with. (A few blocks can be taped at a time, but they obviously cannot be adjacent ones because the tape goes around the outside of each slab.)

3 Mix each colour with water in a separate paint kettle, thinning the emulsion with about 1 or 2 parts water to 20 parts emulsion. Form the scrim (mutton cloth) into a pad and dip it into the cream colour first. Rub the colourwash over the whole of the slab, taking it right up onto the tape to make sure you don't miss any edges.

4 Keep that scrim just for the cream colour, and use another one for the other two colours. Do not load the scrim with a lot of paint – just use a little. Rub medium beige in sparingly in small random patches over the slab.

5 Do the same for the dark beige, applying a couple of patches centrally and along the left and bottom edges as shading. Lightly finish with just a little medium beige along the top and right edges.

6 When you have finished a block, move to a block in a different area. Not only will this allow the edges to dry before you tape adjacent ones, but it will also create a more natural, balanced effect over the entire area.

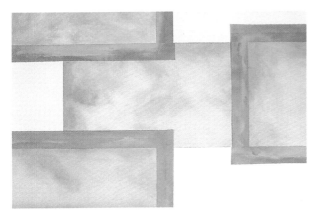

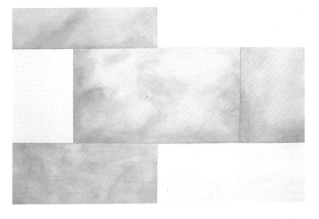

7 As soon as you have finished applying the colour, and before it has dried, carefully pull off the tape and check whether the paint has bled over the edges. If it has, remove it using a clean piece of the cloth dipped in water.

8 Continue the taping and painting process until all the slabs have been painted. Make sure you do not tape over painted areas before the paint has dried. For a realistic effect, try to make the shading different on each stonework slab.

Pillars

A pillar is one of the motifs most associated with trompe l'oeil, and can look very dramatic. Since trompe l'oeil aims to be as subtle and realistic as possible, pillars should ideally look as though they are actually holding something up. Suitable sites are at the top or bottom of the stairs, or where part of the ceiling is lower and the pillar can appear to support it.

The pillar can be measured out and drawn straight onto the wall, as shown in the steps here. Alternatively, sketch the top and base on some lining paper, or trace the templates at the back of the book, and transfer them to the wall. (You can't use the same template for the top and base, because the pillar tapers.)

YOU WILL NEED
Base coat in white
Vinyl matt emulsion (latex velvet) in dark beige, medium beige and cream
Roller and paint tray
Metre ruler (yardstick)
Pencil, such as a watercolour pencil
Spirit level (carpenter's level)
Tracing paper and very soft (6B) pencil
Low-tack masking tape
Fitch brush
Decorator's brush, 5cm (2in) wide
Scrim (mutton cloth)
Artist's brush, size 8

• For your pillar, enlarge the one in this diagram (or use the templates at the back of the book). The height of the pillar will obviously depend on the height of the room and whether it is to be painted to ceiling height or to chair rail height.

18–22 cm (7–8½ in)

eye level

20–24 cm (8–9½ in)

4–5cm (1½–2in)

30–34cm (12–13½in)

1 Use a roller to apply a white base coat to the wall. (If you are only painting the pillar, not a mural, apply the base coat with a radiator roller after completing steps 1–3.) Copying the diagram (or using the templates at the back of the book and some lining paper), draw the pillar on the wall. Use a spirit level (carpenter's level) to ensure that the horizontal lines are level and that the centre vertical line is exactly vertical. (The vertical edges of the pillar won't be exactly vertical because they taper.) Draw only half of the curved and angled lines at the top and base.

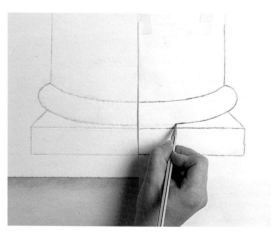

2 If necessary, adjust the curves on the half of the base you have drawn, then trace the outlines on tracing paper using a very soft pencil. Turn the paper over and tape it in position on the other side of the pillar. Now draw over the lines, pressing quite hard, to transfer them to the wall. Repeat for the top of the pillar. This procedure will ensure that the pillar is completely symmetrical.

3 Run masking tape along the outside of the vertical and horizontal straight lines. Using the fitch brush, paint the edges of part of the pillar with dark beige, then apply medium beige alongside. Now, with the 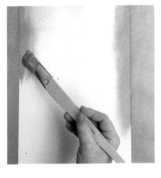 decorator's brush, fill in the remainder of that part of the column with cream, using vertical brushstrokes. Use the emulsion undiluted from the pot, but dip your brush in water occasionally so the colour is not too dry. Soften with scrim (mutton cloth) to get the colourwash texture. Do not attempt to complete all the edges of the pillar first, or the paint may dry too much to blend.

4 Use the scrim (mutton cloth) to soften the edges of the two colours, blending them into each other before they dry.

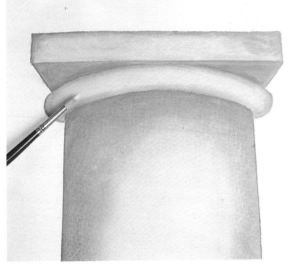

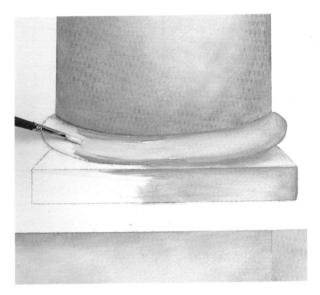

5 Continue dealing with only small areas at a time, so that you are blending colours while the paints are still wet. At the top of the pillar, use the scrim to rub cream over the front of the oblong, and then use a second piece of scrim, on which you have applied the medium beige sparingly, to create subtle darker patches on top of the cream. With the artist's brush, paint a little dark beige shading along the top edge. Also apply dark beige, plus a little cream, on the underside of the oblong, keeping it dark and shadowy. Now use the same brush to paint a dark beige outline around the ring at the top, making it heavier on the upper edge; fill in the centre of the ring with cream. As you work, keep softening the edges with the scrim to blend the colours.

6 The base of the pillar is completed in much the same way. Use scrim to apply cream followed by medium beige patches to the oblong, and the artist's brush to paint some dark beige shading along the top edge of the oblong, blending to light at the bottom edge. Make the top side of the oblong shadowy near the pillar but lighter at the front. Also use the artist's brush to paint this ring, using dark beige around the edge and making it heavier on the lower edge, and highlighting the centre with cream. As before, blend the colours as you work.

Alternative Pillar Designs

Many modern pillars are loosely based on these six examples, and endless variations are possible. All columns taper slightly from top to bottom, but this can be exaggerated a little to give an illusion of more height. A difference of about 5cm (2in) between top and bottom is probably the maximum that will look realistic, but experiment with masking tape to see what looks right.

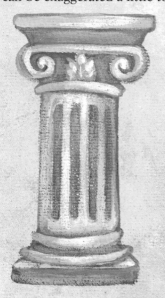

CORINTHIAN
The column is round and fluted, and there is a small relief design on the top and base.

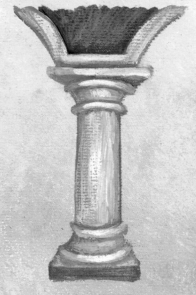

CLASSICAL
This is useful as a basic column, to which more detail can be added if desired. Extra moulding rings can be added, and it can be 'squashed' to make it less elongated.

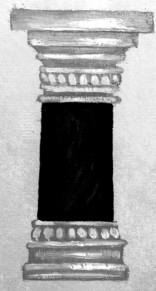

DORIC
This flat column is easy to paint because all the sections are straight It is ideal for the edge of a paint effect or mural or for framing a trompe l'oeil view.

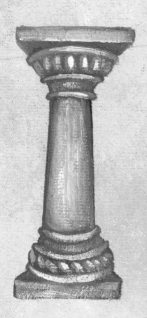

ITALIAN
A medium round, tapering column with moulding detail on the top and base.

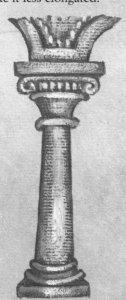
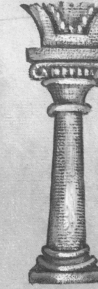

MOORISH
A slimmer column, this has a top that is wide at the highest point, then tapers to meet the column.

GREEK
A Greek column is quite chunky and has a large, ornate top.

Stone Ledge

A trompe l'oeil stone wall that finishes at chair rail height needs a faux stone ledge to finish the top and to add depth to the composition. It also provides something on which a pillar can sit. Because the ledge is below eye level, the flat top is visible, and the face edge is represented as a band of shading.

YOU WILL NEED
Base coat in white
Vinyl matt emulsion (latex velvet) in dark beige, cream and medium beige
Roller and paint tray
Spirit level (carpenter's level)
Metre ruler (yardstick)
Pencil
Low-tack masking tape
Artist's brush, size 8
Scrim (mutton cloth)

1 Apply a white base coat as for faux stone and pillars. Using a spirit level (carpenter's level) and metre ruler (yardstick), draw in two horizontal lines. The bottom one represents the front edge of the top of the ledge and the second one the back edge of it. If you are using the ledge in conjunction with a pillar in a mural, as here, the ledge shown is the same depth as the front of the oblong at the base of the pillar. (However, the top of the shelf actually represents a deeper area.) Mask above and below the front edge of the shelf by taping along the lower line and along the edge of the faux stone wall, as shown.

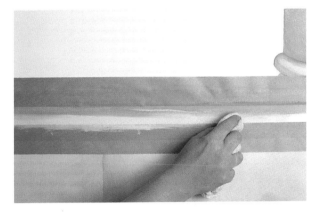

2 With a corner of scrim (mutton cloth), rub in dark beige at the top of the masked area, cream at the bottom of it and medium beige between them (all undiluted). Blend the edges of the colours softly together. Keep the top edge quite dark, and shade it through to the cream at the bottom edge.

3 When the paint has dried, remove the tape. Now mask the edges of the shelf top by taping along the upper line, and below the line beneath it (ie, covering the area you have just painted). Use the artist's brush to paint on the dark beige at the back of the shelf top, the cream at the front edge and the medium beige in between. Soften the colours into each other.

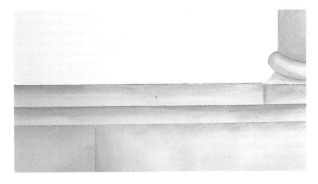

4 Remove the tape. If necessary, use the scrim and artist's brush to retouch the paint and to burnish the painted surface so that it looks like the rest of the stonework. If the dark beige is a little strong, soften with medium beige on the scrim to lighten it.

Pediments

A trompe l'oeil pediment above a door looks very dramatic. If there is more than one door in a room, you don't have to put a plinth above each one. In a hallway, for example, a plinth will make the door into the sitting room more dramatic, but a kitchen or cloakroom door could be left plain.

Pediments look good in conjunction with other paint effects – such as a dramatic terracotta or deep pink colourwashed wall – but they also work well against a plain surface. The colours of the door, door surround and pediment should all tone together well.

You can either copy the relatively simple pediment shown here or make it more elaborate, adding extra mouldings and details. Normally pediments are used above doors, but there is no reason why you couldn't adapt the design to your own home. For instance, it could be painted around a mirror to give an architectural feel in a bathroom or hall.

Once you have decided on the design and the position, draw the pediment roughly on lining paper, cut it out and stick it in position. This helps you to imagine what it will look like, so that you can adjust the shape or proportions if necessary. Then either draw it straight onto the wall, or make the drawing into a template. To ensure that the template is symmetrical, fold the drawing in half, draw in one side of the pediment, and then trace this onto the other side.

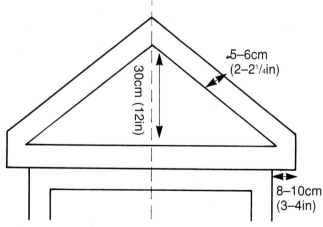

• The dimensions will vary with the door, but you will probably need to allow for the pediment to project beyond each side of the door by about 8–10cm (3–4in). The width of the pediment surround should be 5–6cm (2–2¹⁄₄in). On an average-sized door the overall height of the pediment should be about 40cm (16in) and the height of the inner triangle 30cm (12in).

YOU WILL NEED
Base coat in white
Vinyl matt emulsion (latex velvet) in cream, medium beige and dark beige
Roller and paint tray
Tracing paper and very soft (6B) pencil
Lining paper (optional)
Metre ruler (yardstick)
Spirit level (carpenter's level)
Watercolour pencil in brown
Low-tack masking tape
Scrim (mutton cloth)
Decorator's brush, 5cm (2in) wide
Artist's brush, size 8

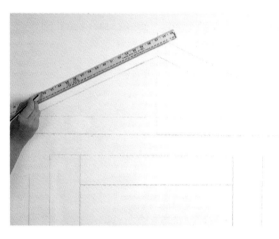

1 Paint the wall with the white base coat using a roller. If you are just painting the pediment, apply it after completing the rest of this step, using a radiator roller. Draw half the pediment straight on the wall using a metre ruler (yardstick), spirit level (carpenter's level) and pencil, then make the other half by tracing it and transferring to the wall (see page 140 and also page 20, step 2). Alternatively, make a template from lining paper and transfer the lines to the wall above the door in the same way. Run tape outside the edges of the inner triangle.

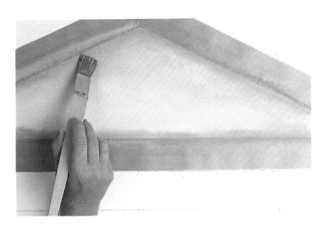

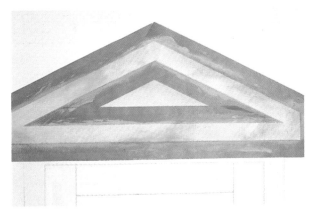

2 Mix up a cream colourwash using 1 part water to 3 parts cream paint. Use the scrim (mutton cloth) to apply a colourwash of cream emulsion. Now, with the decorator's brush, apply the two darker emulsions (undiluted) around the edges, subtly blending the darker edges into the lighter centre with the decorator's brush and the scrim. Remove the tape and allow the paint to dry for 20 minutes.

3 Run tape around the inner and outer edges of the pediment surround. Using the scrim (mutton cloth), apply a cream colourwash. Now apply the undiluted medium beige emulsion sparingly in small random areas using the scrim. Do the same for a tiny amount of dark beige. Remove the tape.

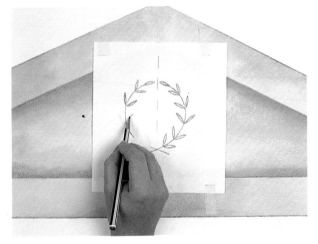

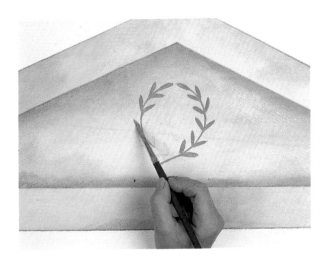

4 Trace the motif at the back of the book using the watercolour pencil. Position the tracing in the centre of the pediment and transfer the design (see page 140). Alternatively, draw the design on the wall freehand with the watercolour pencil.

5 Paint over the pencil marks using the artist's brush and the dark beige emulsion. Before it dries, use the decorator's brush to feather across the wet paint and soften the outline slightly.

6 When the paint is dry, use the artist's brush to apply undiluted cream emulsion inside the darker area to create highlight detail as shown. This creates a three-dimensional look that is similar to the *grisaille* technique traditionally used for relief effects in trompe l'oeil (see page 6).

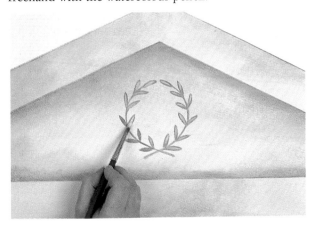

Alternative Pediment Designs

You can adapt any of these pediments or design your own. The basic principles of drawing and painting pediments described on pages 24–25 are the same for all the examples shown.

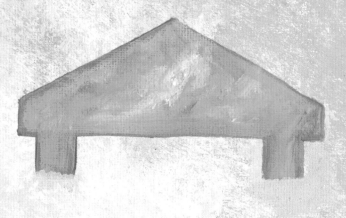

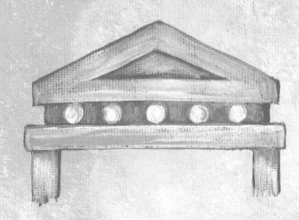

A simple outline pediment painted in faux stone colours (see page 18) makes any doorway or entrance look grand.

This is painted in sections, using masking tape to keep the lines straight, then the circular motifs are painted in the same way as highlights (see page 25).

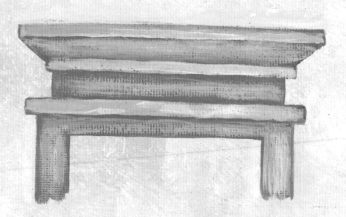

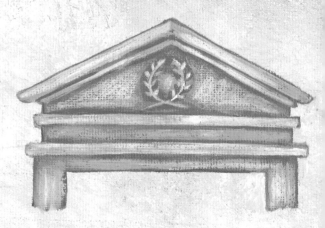

Angled edges and the use of shading and highlighting will make this pediment look as though the top projects right out into the room.

The leaf emblem at the centre of this pediment gives it a classical look, and the narrow shadow line adds to the effect of raised detail.

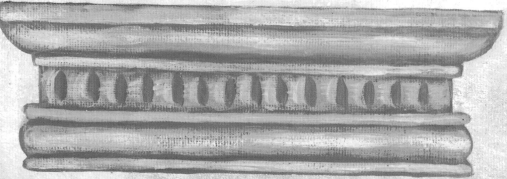

Based on Corinthian pediments, this style was popular during the eighteenth and nineteenth centuries. Like the broken pediment, it suggests faux plaster or wood.

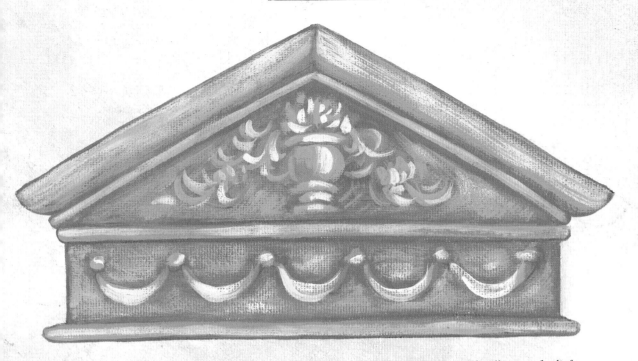

A pediment that looks like a plaster or wood construction, with curved ends that create the illusion of relief moulding. The detail can be included or left off as appropriate.

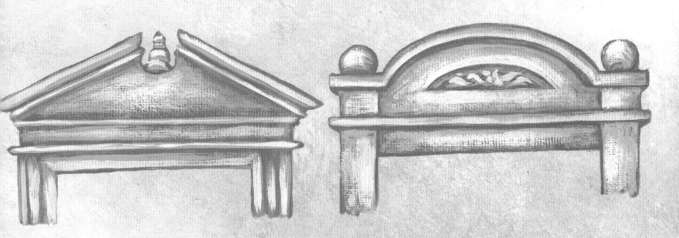

This style suggests a wood or plaster construction used indoors. Broken pediments were popular during the eighteenth century.

This variation on the classical pediment has a soft, curved top. The round details on the left and right suggest a relief pediment.

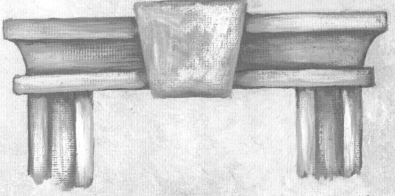

The large scale makes this appear to be an exterior pediment. The width can be reduced for an interior version, but the projection of the central keystone should remain constant.

Simple Sky Effect

Sky effects make very effective backgrounds for murals and attractive feature ceilings in any part of the home. The simplest sky effect is the one shown here. It is achieved by applying a soft blue wash with scrim (mutton cloth), then 'clouding' it with the cloth. This technique gives enough colour variation for a sky that will appear above a mural, but is very subtle and does not incorporate cream-coloured clouds.

If you want the sky to extend down onto the walls, as here, the colour is brought about 75cm (30in) down the wall and the edge softened (see page 13, step 4). Since horizons tend to be paler than the sky overhead, cream is gradually added.

When you colourwash a ceiling, use the scrim (mutton cloth) to apply only the blue wash in a small, circular rubbing motion. Work back over the colourwashed area to lighten or darken portions as desired. Here you soften from the outer edges of the ceiling inwards, in areas up to a metre (yard) from the edge of the wall. Aim to create jagged edges that arc into the centre of the ceiling, as though the clouds are radiating outwards. Do this very subtly.

If there is a cornice, a dramatic effect can be created by applying three or four colours with a brush, then blending them with a cloth. Good colours for this would be grey, dark blue, and either light turquoise or sky blue for the sky, plus cream for the clouds, with a small amount of ochre or grey to add a moody touch to the clouds. It looks more realistic if you work the darker colours mainly around the edge, and blend the lighter colours towards the centre of the ceiling. This lends a feeling of height and depth. When using brushes to apply the colours for this more dramatic approach, you do not need to thin the paints down. To prevent the brush marks from showing, use a stippling action, dabbing the brush up and down. Remember to shade the colours into each other while the paints are still wet.

YOU WILL NEED
Base coat in white
Vinyl matt emulsion (latex velvet) in pale sky blue and cream
Roller and paint tray
Paint kettle
Low-tack masking tape
Scrim (mutton cloth)

1 Use a roller to apply a white base coat to the walls and ceiling. In the paint kettle, dilute the blue emulsion (latex) with about 1 part water to 10 parts paint. With tape, mask out any features you plan to paint afterwards or any that are already painted. Use the scrim (mutton cloth) to apply the thinned-down blue paint with an oval rubbing motion to the wall. Go back over what you have done as it dries, rubbing with the cloth to make sure all the paint is well worked into the stipples of the roller finish.

2 In order to make the horizon paler than the overhead sky, pick up a small amount of cream emulsion (latex) as you work your way down the wall towards the horizon with the blue wash. Fade it away subtly with the scrim.

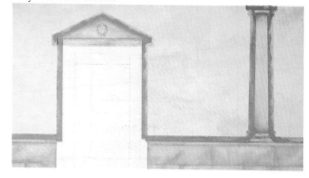

3 Do all this very subtly, leaving a soft edge. This will enable you to add a distant horizon or some foreground architecture later.

Faux Panelling

This technique is excellent for adding character to flat doors and panels such as fire doors, fitted cupboards or screens. It also looks fabulous on walls, such as below a chair rail, perhaps with a colourwash on the wall above, in a mid to light tone used in the panelling. In French châteaux you will find many examples of faux panelling, sometimes combined with marbled insets.

Another advantage of this technique is that you can choose from a wide range of colours. For example, faux mahogany panelling might utilize a rich red brown with burnt umber and black, while a light painted panel could incorporate a range of blues and creams, with some raw umber added for shading. In the step-by-step instructions, the colours stipulated are those used in the photograph, but these could obviously be changed.

If you are faux panelling onto a wooden surface, it has to be prepared first by sanding and then by applying two or three coats of acrylic undercoat primer; for walls, vinyl matt emulsion (latex velvet) is used. For light-coloured panelling, as here, the undercoat should be white, while for a darker colour it can be darker. For example, pine panelling would have a creamy-gold base, and mahogany would have a mid brown base. After the undercoat has been applied, the panels are marked out in pencil.

YOU WILL NEED
Base coat in white
Vinyl matt emulsion (latex velvet) in cream and dark beige
Acrylic paint in raw umber
Fine sandpaper
Decorator's brushes, 10cm (4in) and 5cm (2in) wide
Retractable tape measure
Metre ruler (yardstick)
Pencil, such as a watercolour pencil
Low-tack masking tape
Palette
2 fitch brushes
Artist's brush, size 8

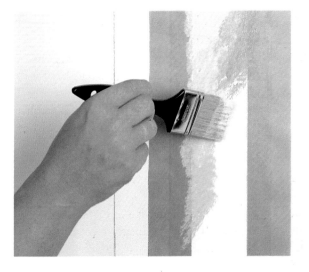

1 If you are painting a real door, sand it lightly, then use the 10cm (4in) decorator's brush to apply two or three coats of acrylic undercoat primer, allowing it to dry between coats. If you are creating a trompe l'oeil door on a wall, paint the wall using a roller. Mark out a door frame with pencil if you haven't already done so. Mask around it, then use a 5cm (2in) decorator's brush and a fitch brush to stipple the two vinyl matt emulsion (latex velvet) colours onto the door frame. At the top of the door frame, add some shading with the dark beige to represent shadows cast by the pediment.

Diagram measurements:
10–12cm (4–4³⁄₄in)
4–5cm (1¹⁄₂–2in)
10–12cm (4–4³⁄₄in)
10–12cm (4–4³⁄₄in)
4–5cm (1¹⁄₂–2in)
15–18cm (6–7in)

• As always, the dimensions of the panelling will depend on those of the door or other surface you are decorating, but the diagram shown here gives rough measurements for an average-sized door.

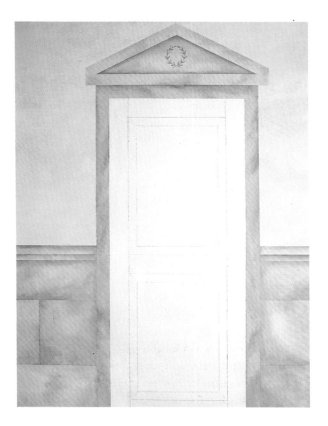

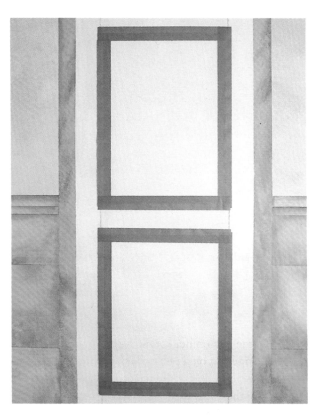

2 Following the diagram shown on page 29, and adjusting the measurements as necessary, measure and mark out the door panels.

3 Run low-tack masking tape around the outside of the upper and lower panels as shown.

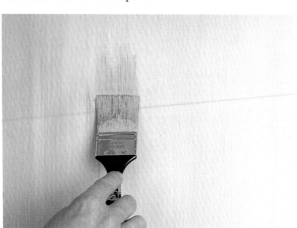

4 Using the 10cm (4in) decorator's brush and vertical brushstrokes, coat the panels with a thin mix of dark beige (2 or 3 parts paint to 1 part water), dipping the brush tip in water and pulling the paint out with each stroke, to leave visible brush marks.

• As the diagram on the right shows, both fielded panels are painted the same (see page 32, step 9). Each lefthand beading is light on the inside, as is each top beading. Each righthand beading is medium (ie a midtone) on the inside, while each lower beading is dark on the inside. All the beadings are dark on the outside. A highlighted flat rim surrounds them.

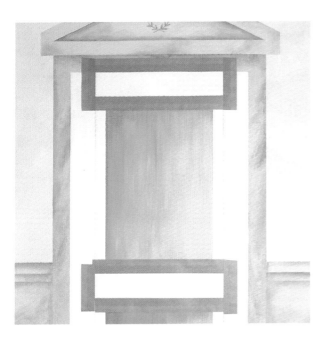

5 Mix some raw umber acrylic with undiluted dark beige emulsion on a palette and paint it along the top edge and one side of the panel, using vertical strokes; use the 10cm (4in) decorator's brush, and the 5cm (2in) brush for the inner panels. Work it into the base colour of dark beige, still using vertical strokes. With the same brush, work undiluted cream into the bottom and opposite side of the panel, blending it into the dark beige. Remove the tape – the longer pieces can be reused. Now mask around the rails (the horizontal portions above and below the panels).

6 Repeat steps 4 and 5 for the rails, but using the 5cm (2in) decorator's brush and the fitch, and with horizontal brushstrokes to suggest the grain of the wood. Remove the tape.

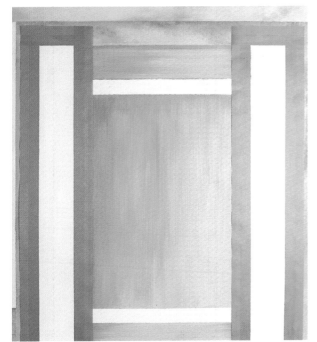

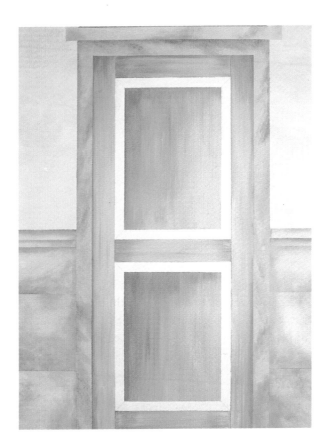

7 Mask around the stiles (the vertical portions on either side of the panels) and repeat steps 4 and 5, using vertical brushstrokes.

8 The door is now nearly complete. Only the beadings remain to be done.

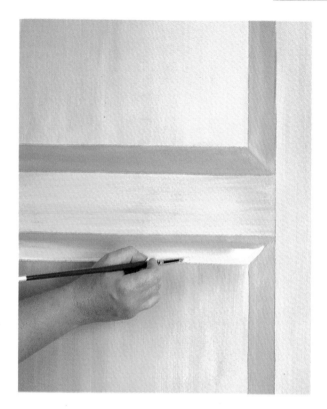

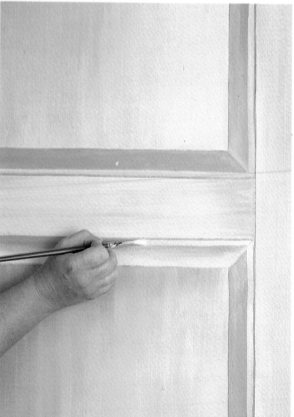

9 Put some cream emulsion (latex) on your palette. In addition, mix some dark beige and raw umber to form a medium brown. Finally, add a little more raw umber to some of this medium brown to produce a slightly darker brown. Use these three colours – light (cream), medium (medium brown) and dark (dark brown) – for the highlights, midtones and shadows of the beadings. Follow the diagram on page 30 for their exact placement. Apply the colours using the artist's brush, and blend them using the fitch.

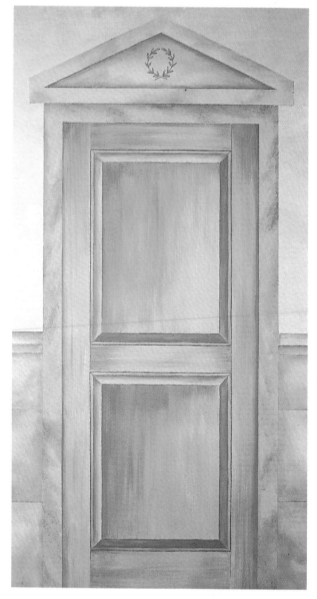

10 Finally, use the artist's brush to paint a cream highlight all around the outer rim of the beading on both panels. Leave a fine line of dark around it to make it look even more like the rim of the faux beading.

11 The fact that the light source for this panelled door is supposed to be from the left is very apparent, because the highlights, midtones and shadows on each fielded panel are consistent with this.

TECHNIQUES AT A GLANCE

Faux Panelling Brushstrokes

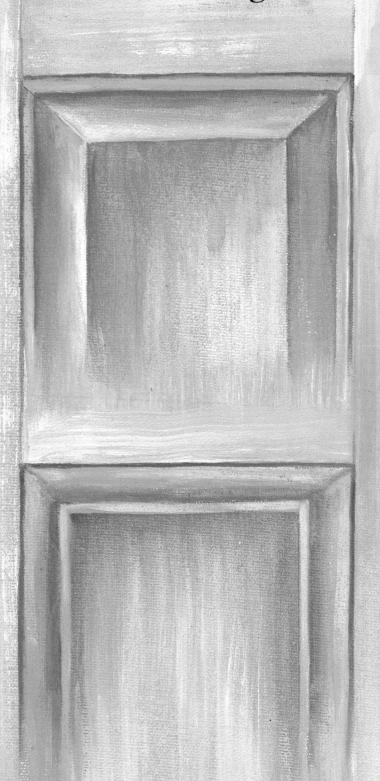

FIELDED PANEL

• Paint the panel with a thin mix of dark beige, applying it in long, sweeping strokes with the brush flat and using it to pull the paint out. Paint in the direction of the grain. Pick up more paint or water with the brush to soften the brushstrokes.

• Add some raw umber and apply the darker tones and shadows, blending it into the dark beige and still following the grain. Pick up more paint to thicken it slightly if necessary. Apply the cream areas in the same way. Using light, medium and dark tones, paint in the beading around the panel, again following the grain. Paint a highlight all around the rim.

ALTERNATIVE MOULDING

• Paint the inner panel with a shadow around the edge, blending it into the midtone and light tone in the centre.

• Shade the inner moulding line, softening it to create a curve, then add a light line at the outer edge of the panel to finish the piece.

FREEHAND FLOWERS AND FOLIAGE

Hand-painted flowers and foliage look wonderful however they are used, whether in full-sized murals or as tiny sprig motifs. Not surprisingly, they often feature in trompe l'oeil. Yet, despite their luscious looks, they are not particularly difficult to do.

If you wish, use photographs of the flowers and foliage as a guide when painting, but don't worry about copying them exactly – or achieving exactly the same effects as we have here. There is plenty of room for personal interpretation.

The techniques covered in this section are shown being built up into a mural depicting an urn of wisteria and a shelf holding pots of French lavender, ivy and miniature roses. The techniques could also be successfully combined with those covered in the previous section to create a large mural – perhaps with ivy and wisteria creeping over columns and roses growing up a stone wall. Equally, they could be adapted for very simple projects, such as French lavender growing out of a single pot painted onto a small plaque. Indeed, miniature roses have been added to a vase on the shelves shown on page 58. The variations on the theme are endless too. You could paint garlands of mixed flowers, or bouquets of peonies, carnations or tulips, for example.

To begin drawing the flowers and leaves, study the step-by-step photographs to see how the colours build up and where the highlights and shadows are positioned. It's important to practise painting these flowers and leaves on paper, in any colour, before attempting them in a project. Experimenting with different effects whenever you have a spare moment is the best way to develop your painting skills.

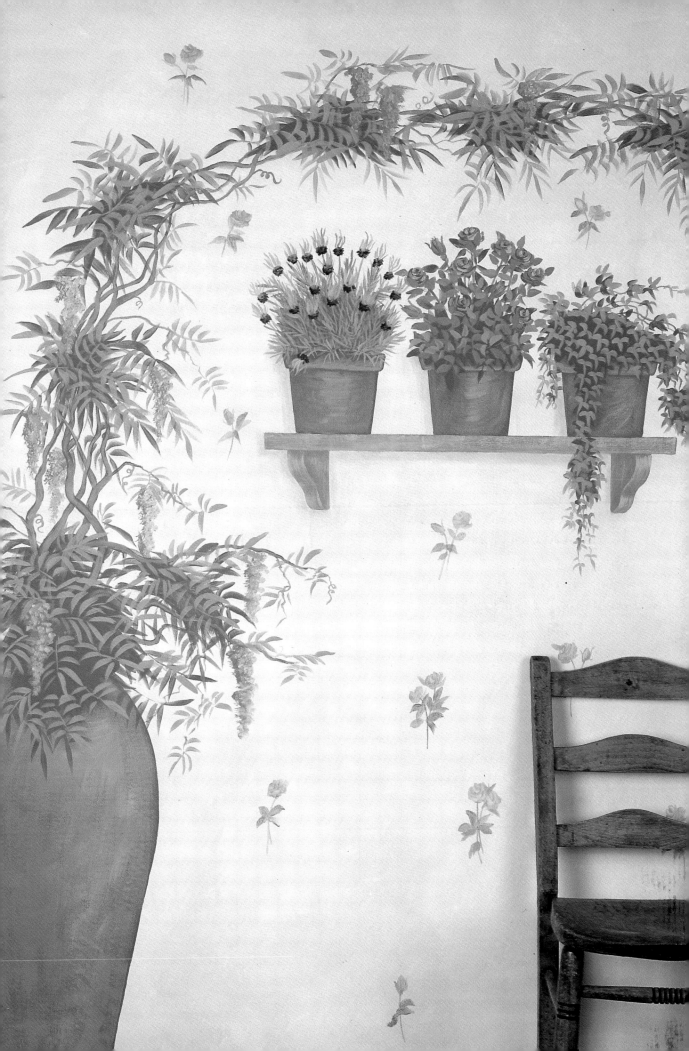

Background and Simple Shelf

A single shelf at eye level, viewed from straight on, is very easy to draw, as there is no need to think about perspective. In fact, in most simple trompe l'oeil, the viewpoint is at eye level. If you wish to change it to above or below eye level, you'll need to use perspective drawing (see page 58).

When blocking in the tan colour on the shelf, aim for a streaky finish since this will make it look more realistic.

YOU WILL NEED

Vinyl matt emulsion (latex velvet) in tan, dark brown and cream
Metre ruler (yard stick)
Spirit level (carpenter's level)
Pencil, such as a watercolour pencil
Palette
Fitch brush
Artist's brush, size 8

1 Paint a single-tone colourwash onto the background, then, using a ruler, spirit level (carpenter's level) and pencil, draw a double line to represent a shelf edge at eye level. Make a template for the bracket (use the pattern at the back of the book or design your own). Draw around it for one bracket and then turn it over and draw around it again for the other.

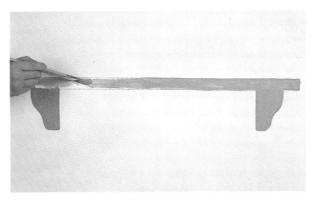

2 Dilute the tan emulsion (latex) on a palette with a very small amount of water. Using the fitch brush, block in the shelf with the diluted paint; your brushstrokes should be in line with the woodgrain (ie, horizontal for the shelf, vertical for the brackets). Add a little dark brown to the diluted tan, and paint this along the edges, using the artist's brush.

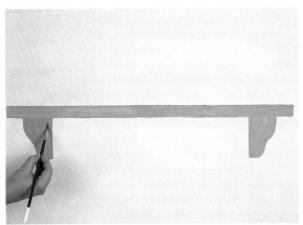

3 Add more dark brown to the diluted tan and, using the artist's brush, paint the sides of the brackets with this colour to make them look shadowy. Add a little of this to the front of each bracket, in the 'hollow' between the two curves.

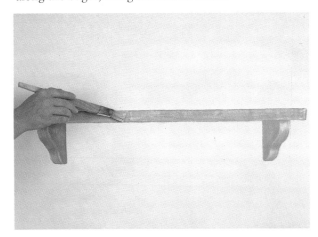

4 Mix cream with undiluted tan and, using the fitch brush, paint highlights on the front of the shelf. Slowly build up a subtle grain effect, picking up more cream with the brush as you go, and using lighter and subtler strokes. Also paint some highlights on the fronts of the brackets, using the artist's brush; concentrate them on the outermost parts of the curves.

Urn, Pots and Foliage

The techniques for painting a terracotta urn and pots and accompanying foliage are useful not only for a mural like the one shown in this section but also as a basis for a variety of potential projects. A single pot with some herbs could be painted at the back of a work surface, on a small faux shelf or on a small plaque to hang anywhere. A single large urn, with ivy spilling from the top, could be painted from floor level in a hallway. A hanging pot with foliage cascading from it works very well as a trompe l'oeil. Outdoors, a patio garden with plain walls, or a passageway to a garden, could carry greenery all year round.

YOU WILL NEED

Vinyl matt emulsion (latex velvet) in terracotta, cream and dark green
Spirit level (carpenter's level)
Pencil
Lining paper
Masking tape
Fitch brush
Decorator's brush, 5cm (2in) wide
Watercolour pencil in green
Artist's brush, size 8
Palette

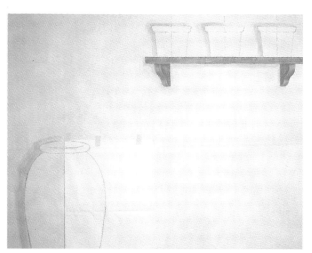

1 With a spirit level (carpenter's level), mark the vertical centres where the urn and each pot will be placed. Using the template at the back of the book, make a template for half of the urn. Also make a template for half of a pot (see page 140). Line up the straight edge of the template with each vertical line, tape in place and draw around it. Remove the template, turn it over and repeat for the other side. Now create soft shadows by building up the cream emulsion (latex) on the background around the shelf, pots and urn, using the fitch brush. The shadows are to the left of the objects, indicating that the light source is from the right. The shadows are softened around the objects with the brush.

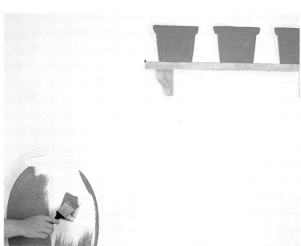

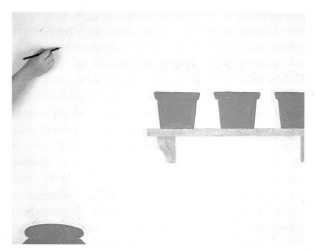

2 Block in the pots and the urn with terracotta emulsion, using the fitch brush on the pots, and the decorator's brush on the centre of the urn with the fitch around the edges. You might also need to use the artist's brush on the edges. Follow the shapes with your brushstrokes, and don't worry if the paint is slightly streaky, so long as the outline is neat.

3 With the green watercolour pencil, roughly sketch the outlines of the foliage coming out of the pots. On our mural, the French lavender is in the pot on the left, the roses in the one in the middle and the ivy in the pot on the right, and there is wisteria in the urn. There is no need to be very precise about these outlines – just sketch them very loosely.

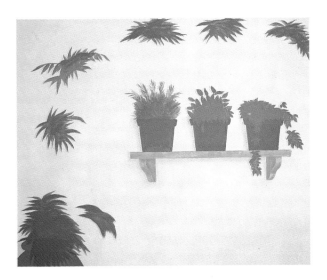

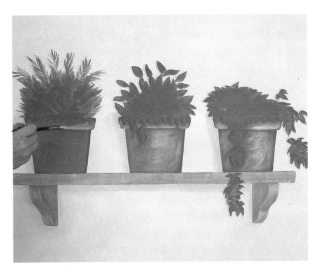

4 Using the fitch for the broad areas and the artist's brush for the points of the leaves, block in the foliage with dark green emulsion (latex) within the outlines you've just drawn. (Instructions for painting the details of each plant are given individually on the following pages.)

5 On your palette add some cream to the terracotta paint. Using the artist's brush on the pots, and the decorator's brush and the fitch on the urn, highlight a fairly large area of each container as shown, so that your brushstrokes follow the shape. As you work towards the centre of the highlighted area, pick up more and more cream with your brush.

Wisteria

This is a lovely subject to paint. Wisteria stems are an interesting subject in themselves, as they are not only intertwined but they start out thick at the base and have tendrils that extend out away from the urn. If you include an urn, it should be quite large and preferably at floor level. The foliage could be painted growing up a wall, over a doorway, around a column or even as a border around an entire room.

YOU WILL NEED
Vinyl matt emulsion (latex velvet) in dark green, lavender, cream, terracotta and light green
Palette
Artist's brush, size 8
Watercolour pencil in brown
Fitch brush

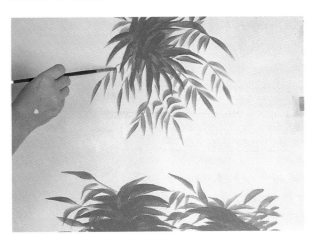

1 Paint additional leaves using the artist's brush and dark green paint. It's a good idea to practise some leaf shapes on a piece of paper first.

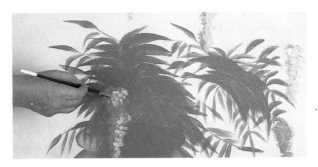

2 Put some lavender and some cream paint on your palette. Decide where to paint the wisteria flowers, then, using the artist's brush in a dabbing action, apply lavender first. While the paint is still wet, pick up some cream on the same brush and dab this onto parts of the lavender so that the colours will blend. Continue picking up cream on your brush and using the dabbing action, to gradually build up the highlights on the flowers.

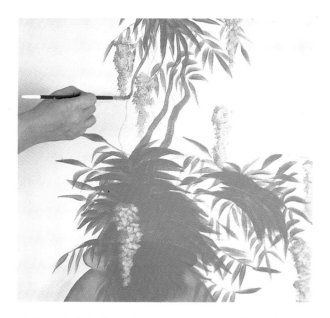

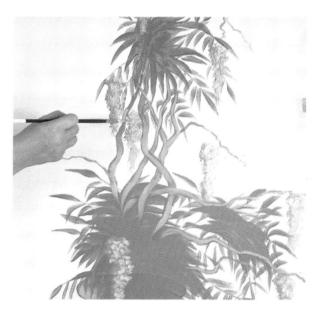

3 Very lightly draw the twisting, sinuous line of the wisteria stems using a brown watercolour pencil; there is no need to draw in the full width of the stems, as this will be done when painting. On the palette, mix the terracotta paint with the green and a touch of cream, to create a dusty brown colour. Paint the stems in this shade, blocking in larger areas with the fitch brush and using the artist's brush elsewhere.

4 Add some more cream to the dusty brown on the palette, and paint in thin, streaky highlights along the stems, using the artist's brush. Where one stem crosses over another, emphasize the highlight on the upper stem, and leave the underneath stem shadowy, creating a feeling of depth.

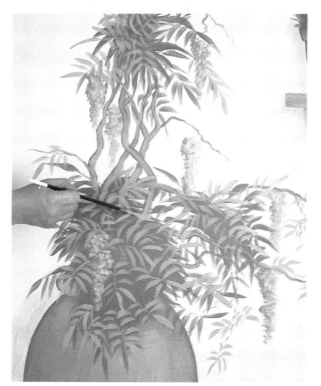

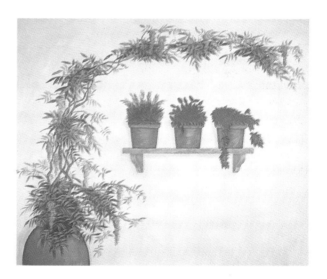

6 On a palette, add a touch of the terracotta to the light green, then add a little water. With the artist's brush, paint a few small, random leaves and a few curling tendrils in this colour.

5 Use the artist's brush and the light green paint to overlay lighter leaves on the dark green ones and highlight the foliage mass. Paint some so they overlap the flowers in a realistic way. Graduate the sizes of the leaves, and paint just a few on the twisted stems.

Ivy

Ivy comes in all shapes and sizes, from very large to tiny spiky leaves. It works really well in murals, and looks good combined with faux stonework. A pot is not always necessary, as ivy works well either with or without one, complementing stonework nicely. It is also good as extra foliage around the top of a large pot of flowers. To help you create the effect of ivy cascading from its source, be sure to practise the leaf shapes with a brush.

YOU WILL NEED
Vinyl matt emulsion (latex velvet) in
 terracotta, dark green and light green
Watercolour pencil in brown
Artist's brush, size 8
Palette

1 With the brown watercolour pencil, lightly sketch the twisting stems of the ivy coming out of the blocked-in foliage. Using the artist's brush, paint these in a terracotta/dark green mix of varying hues, tapering them so that the ends are fine and pointed.

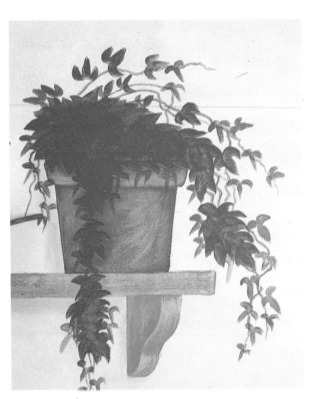

2 On your palette, mix a little water with the dark green so that it flows easily from the brush. Use the artist's brush to paint leaves of varying sizes at the edges of the blocked-in foliage, and radiating out along the stems. (It's a good idea to practise these first on a piece of paper.)

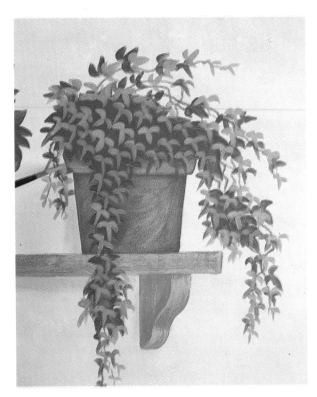

3 Mix a little water with the light green emulsion (latex) on your palette, and use the artist's brush to paint leaves of this colour over the blocked-in foliage and down the stems. Vary the size of the leaves, and graduate the size along the trailing stems so that the smallest leaves are at the tips.

Miniature Roses

The technique shown here for painting roses and their foliage is the basis for all sizes of rose. It is suitable for decorative friezes as well as mixed with other flowers on murals and in the form of a repeat-pattern sprig decoration for walls.

When choosing the colours of your roses, remember that each rose head is created from three tones (for example, dark red, light red and pink). You can mix black into red to create the dark red, and white or cream into red to create the pink. The same applies to other colours, although for light colours like yellow or white you need to substitute raw umber for the black to avoid creating a 'dirty' or grey shade.

YOU WILL NEED
Vinyl matt emulsion (latex velvet) in dark green, terracotta, red, cream and light green
Watercolour pencil in brown
Artist's brush, size 8
Palette

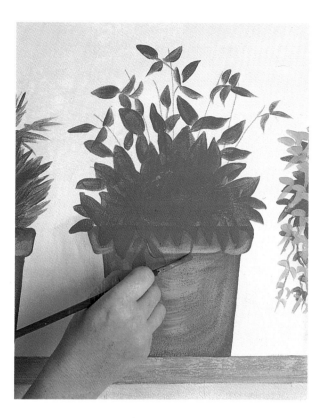

1 With a brown watercolour pencil, draw the stems of the roses. Now, using the artist's brush and the dark green vinyl matt emulsion (latex velvet), paint in the individual leaves on the stems and at the edges of the blocked-in foliage. Bear in mind that rose leaves normally grow in threes or fives.

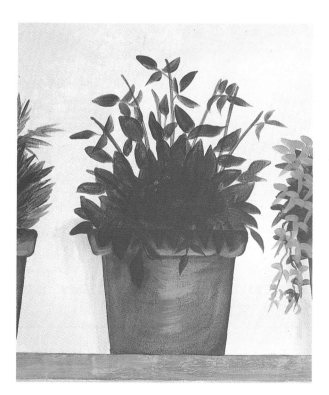

2 Mix terracotta and dark green on your palette and paint the rose stems over the pencilled lines. The mix can be varied and applied with different tones to create two-tone or even three-tone brushstrokes from only one stroke.

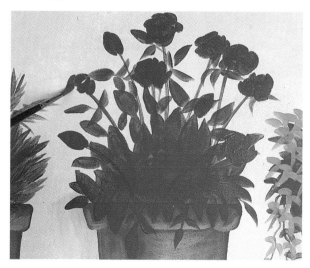

3 Put some red on your palette, and add a little water to it. With the artist's brush, paint the flower heads freehand in this colour. (It's advisable to practise this beforehand on some paper – more detailed painting instructions are given on page 46.)

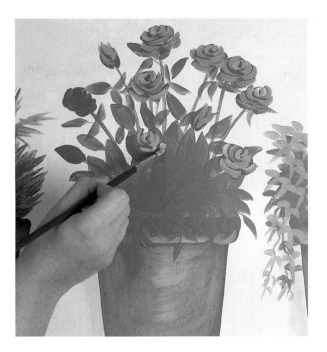

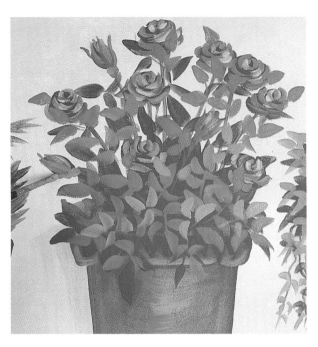

4 Add some cream to the diluted red and paint midtone on the flowers with half-moon shapes radiating out from the centres (the smallest ones at the centres and the largest ones at the edges). Add more cream to the colour and paint highlights on top.

5 Mix light green with a little dark green on your palette, and paint lighter-coloured leaves over the dark leaves, still using the artist's brush. Allow a few of these to overlap the flower heads and buds. (Practise these first on a piece of paper.)

French Lavender

Lavender too makes a successful trompe l'oeil subject, and the technique can be adapted easily. A bunch of drying lavender looks good 'hanging' from a real hook on a cupboard door or from a faux shelf.

The lavender used here is the French variety, which has large flowers with long, trailing petals, but you could use the same technique for other types of lavender. English lavender has small flowers that grow from a long stem; they do not cluster, nor do they have long petals.

Lavender foliage is a lovely dusty green, which is produced by adding cream to dark and light green. The long, spiky leaves are single brushstrokes radiating out from the stems.

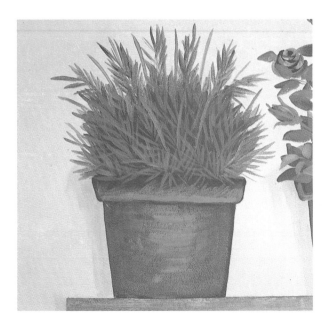

YOU WILL NEED
Vinyl matt emulsion (latex velvet) in light green, dark green, deep purple (or crimson mixed with ultramarine) and cream
Artist's brush, size 8
Palette

1 Mix a little light green vinyl matt emulsion (latex velvet) with dark green on your palette, and use the artist's brush to paint fine leaves over the blocked-in foliage and extending out from the main part as shown. Paint stems for the flowers. (There is no need to draw these first with a pencil.)

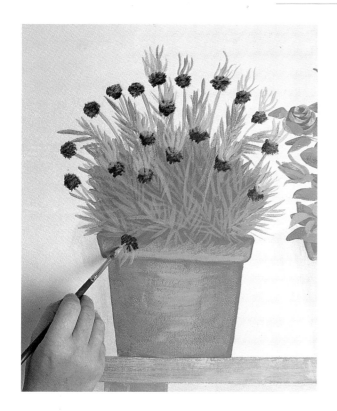

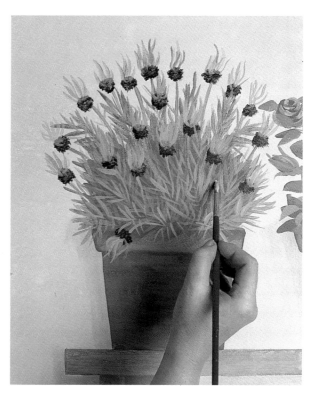

2 Using the artist's brush in a dabbing action, paint clusters of deep purple flowers. Now, with the brush still loaded with purple, pick up some cream and dab this onto the purple flower clusters. Pick up some more cream on the brush, and paint long petals coming from the purple clusters.

3 Mix cream into the light green/dark green mix already on your palette. Using the artist's brush, paint pale leaves onto the darker foliage, allowing some of the leaves to overlap the flowers for a realistic three-dimensional finish.

Wall Decoration

Freehand painting lends a quality to painted decoration that cannot be achieved with a stencil, which repeats an image more or less exactly. Here, sprigs of roses are painted to give additional detail to the wall. The size of the flower heads and the sprigs is varied creating a relaxed, loose, individual feel rather than the unavoidably rigid effect of a stencil.

YOU WILL NEED

Vinyl matt emulsion (latex velvet) in dark green, terracotta, soft gold, cream and light green
Watercolour pencils in green and brown
Palette
Artist's brush, size 8
Decorator's brush, 5cm (2in) wide (optional)
Fine sandpaper (optional)

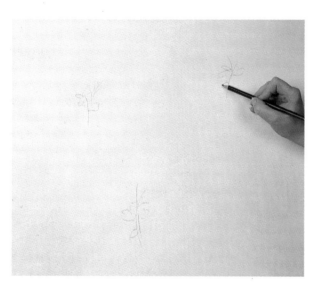

1 Decide where to position the sprigs of roses, and very lightly sketch them on the wall with watercolour pencil, using the green pencil for the leaves and the brown one for the stems.

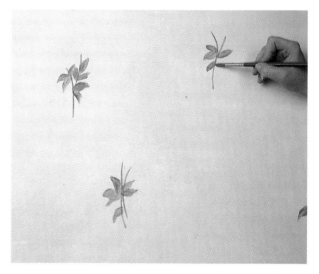

2 Put some dark green and some terracotta emulsion (latex) on your palette, and add enough water to give a very soft effect. Using the artist's brush, paint the base leaves and stems you have just drawn.

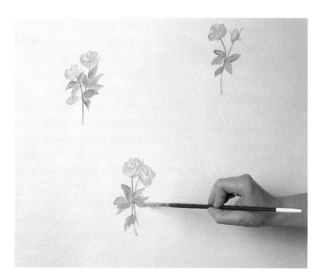

3 Paint the rose heads using the artist's brush and soft gold paint. Add cream to the gold, and highlight the flowers, using the same brush. Mix cream, light green and dark green together, and paint a few light leaves.

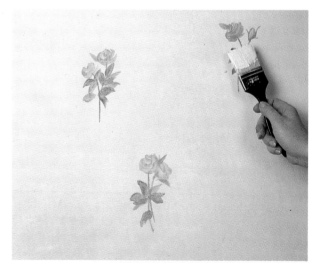

4 Soften the effect even further either by very, very lightly stroking undiluted cream emulsion over the sprigs using the decorator's brush, or by lightly sanding with fine sandpaper.

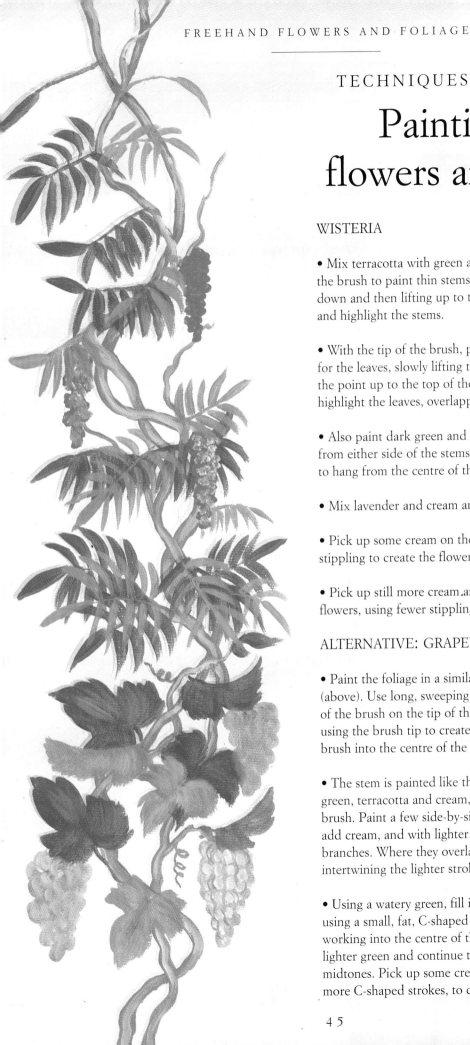

Painting the flowers and foliage

WISTERIA

• Mix terracotta with green and a little cream. Use the tip of the brush to paint thin stems in this colour, lightly pressing down and then lifting up to the point. Gradually add cream and highlight the stems.

• With the tip of the brush, paint large strokes in dark green for the leaves, slowly lifting the brush off the surface from the point up to the top of the leaf. Add light green to it, and highlight the leaves, overlapping them into the dark areas.

• Also paint dark green and light green leaves radiating out from either side of the stems. Overlap some so they appear to hang from the centre of the stems.

• Mix lavender and cream and stipple the flowers with this.

• Pick up some cream on the lavender brush and continue stippling to create the flower midtones.

• Pick up still more cream and use this to highlight the flowers, using fewer stippling strokes.

ALTERNATIVE: GRAPEVINE

• Paint the foliage in a similar way to the wisteria leaves (above). Use long, sweeping strokes starting with the point of the brush on the tip of the leaf. Fill in the leaf shape using the brush tip to create the leaf edge and drawing the brush into the centre of the leaf.

• The stem is painted like the wisteria stem, using a mix of green, terracotta and cream, and very long strokes of the brush. Paint a few side-by-side for thicker stems. Gradually add cream, and with lighter strokes highlight the twisted branches. Where they overlap, leave the stem dark brown, intertwining the lighter strokes with the darker ones.

• Using a watery green, fill in the grapes with the brush, using a small, fat, C-shaped stroke. Overlap these strokes, working into the centre of the bunch of grapes. Pick up a lighter green and continue to overlap the strokes for the midtones. Pick up some cream on the brush and use this for more C-shaped strokes, to create the bloom of the grapes

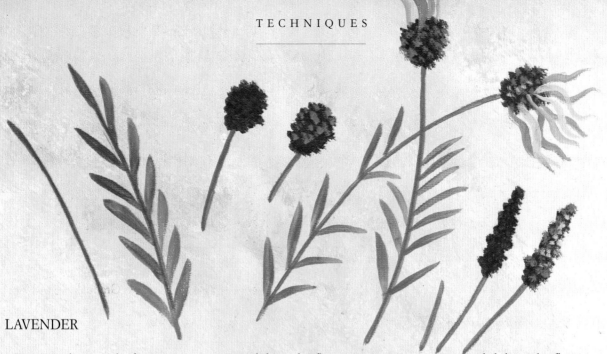

LAVENDER

• Paint one long stroke for a stem and short, fine strokes coming from it for leaves. Start with green, then add cream to it for highlights.

• French lavender flowers are painted like English lavender (see right) but they also have long petals created with sweeping brushstrokes.

• For English lavender flowers, apply purple with a dabbing action, then pick up some cream on the same brush and dab on highlights.

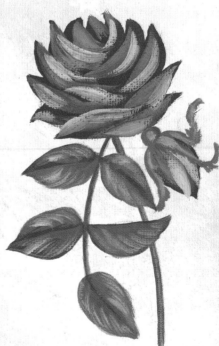

MINIATURE ROSES

• Paint each rose flower in red using sweeping strokes. Use two strokes for each bud. Paint each stem in varying mixes of terracotta and dark green. Paint dark green leaves as for ivy (opposite), joining them to the rose stem using just the point of the brush.

• Add cream to the red, and paint midtones in ever-increasing semi-circles, using the shape of the brush to imprint the paint. On buds, just one light stroke is enough. Add light green to the dark green and paint the bud foliage using the point of the brush. Add midtones to the leaves with this colour too.

• Lighten the red and the green further. Paint smaller pink half-moon shapes as highlights. Highlight the leaves using short, light brushstrokes, starting with the point of the brush and then lightly pressing the brush down, slightly dragging it and finally lifting it off.

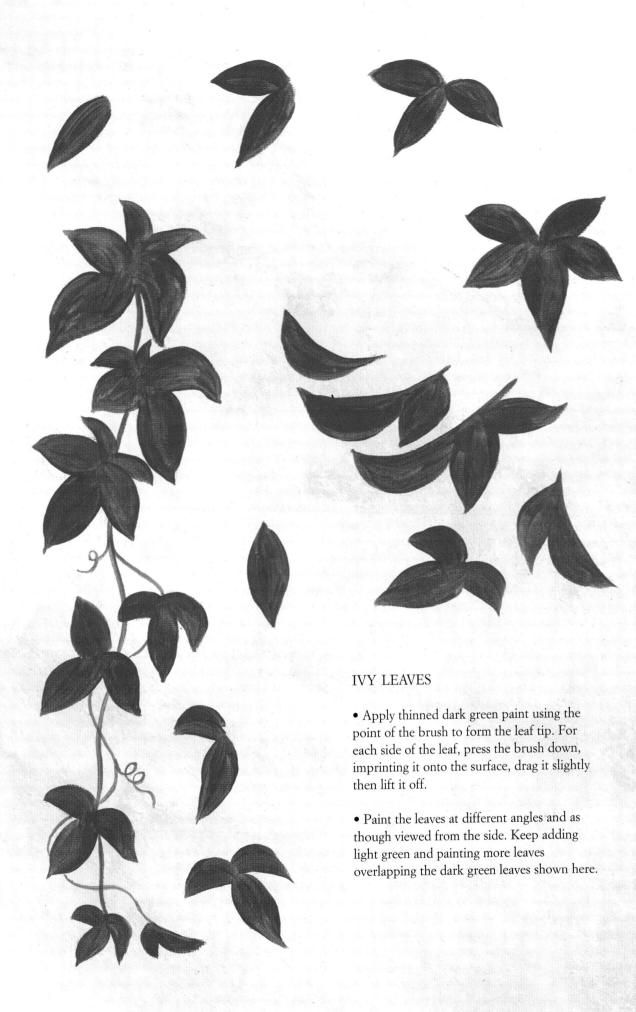

IVY LEAVES

• Apply thinned dark green paint using the point of the brush to form the leaf tip. For each side of the leaf, press the brush down, imprinting it onto the surface, drag it slightly then lift it off.

• Paint the leaves at different angles and as though viewed from the side. Keep adding light green and painting more leaves overlapping the dark green leaves shown here.

FAUX FABRIC AND TRIMMINGS

Faux fabric and trimmings make a dramatic feature in a room, yet because the effect is quite loose and does not require precise measuring, it is easy to achieve. It can be painted as a swag above a real or trompe l'oeil doorway or window, as a curtain draped alongside a door or window, or as a border around a room. Faux fabric is also useful for softening the edges of an archway. It works equally well as an element of a mural or as a decoration on a piece of furniture or box.

Although faux fabric and trimmings are often associated with grand rooms, they are also ideal for small rooms, which can look fabulous with a 'tented' effect. Stripes painted with the folds of fabric add to the illusion. The nice thing about this technique is that there are no straight lines – only dramatic sweeping curves and graceful undulations.

Here, a fairly strong green colourwash has been used for the surrounding walls. The colourwash is painted up to the outline of the swag. If, however, you do not wish to redecorate your entire room, you could simply paint a white basecoat over the design area, as we have for the curtain.

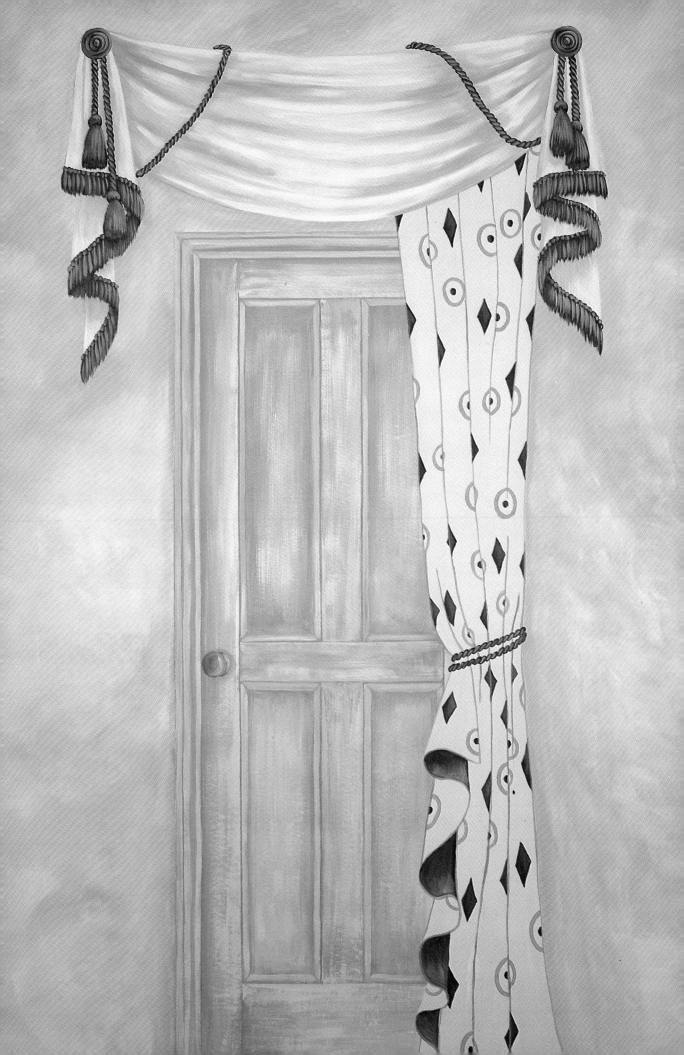

Plain Fabric Swag and Trimmings

When you are painting unpatterned faux fabric, subtle shading effects are needed to create the three-dimensional illusion. In general, you form the shadows in the folds by adding either black or dark brown to the main colour. For the highlights, add cream to the main colour, continuing to add it as you build up the highlights. (Experiment first on paper or card, to discover the range of tones you can achieve.)

If you are colourwashing the surrounding wall, take the colourwash up to the outline of the design. (Don't worry if the paint goes over the edges a little.) Use a fitch brush to take the colour up to any painted edges, such as those of the door.

YOU WILL NEED
Base coat in white
Lining paper (optional)
Vinyl matt emulsion (latex velvet) in dark beige, medium beige and cream (fabric)
Vinyl matt emulsion (latex velvet) in dark blue, mid blue and cream (trimmings)
Pencil
Decorator's brush, 5cm (2in) wide
Fitch brush
Artist's brush, size 8

1 Apply the white base coat with the decorator's brush. Draw the outline of the swag on the wall and sketch in any trimmings. (If you wish, you can sketch the swag on lining paper, then cut out the shape and use it as a template to draw around.) It does not have to be symmetrical. You could paint a shadow around the edge using a deeper shade of the colourwash, but we have not done that here.

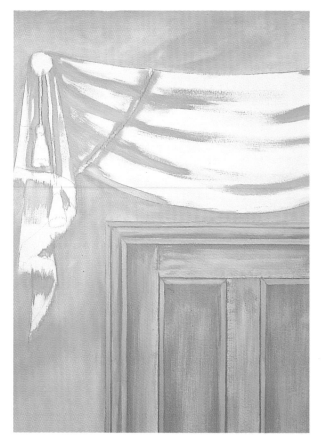

2 Using the artist's brush, paint dark beige shadows along the folds of the fabric swag, around the rope and tassels, and inside the folds of the fabric tails. Soften the edges with the fitch brush.

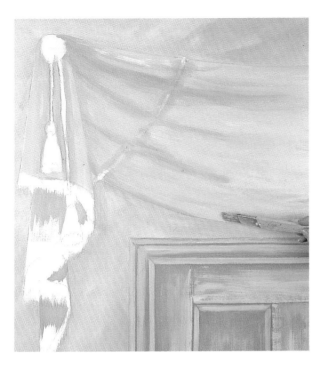

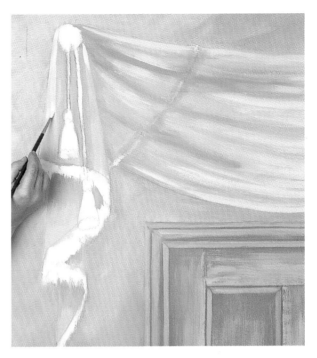

3 While the paint is still wet, use the decorator's brush to apply the medium beige over all the remaining fabric. Soften the edges with the fitch brush so that these midtones blend into the dark beige.

4 Use the artist's brush to paint in cream highlights along the fabric folds and the edges of the fabric, while the paint is still wet. With the fitch brush, lightly blend the highlights into the beige midtones.

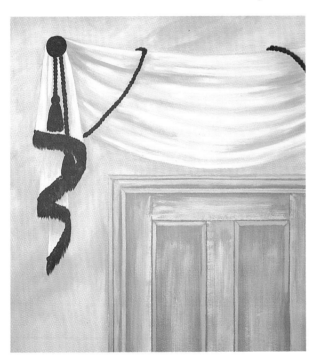

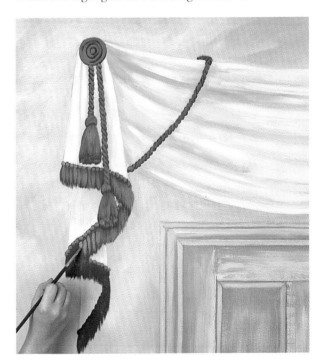

5 The trimmings are done next. Block in the dark blue fringing, cord and tassels using the artist's brush. Use the shape, size and direction of the brushstrokes to 'draw' the segments of the cord, the tassels, the fringe and so on, as shown above.

6 With the mid blue and the artist's brush, paint the midtones so that the dark blue is left as an outline around them. Again use the brushstrokes to 'draw' each part of the trimmings.

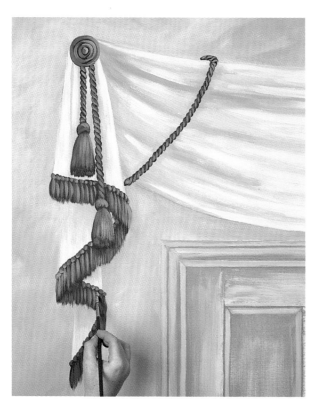

7 Still using the artist's brush, add some cream to the mid blue, and use this to paint highlights on the trimmings, continuing to follow the shapes of the trimmings with the brushstrokes.

8 For the trimmings, it is not important whether the paint is wet when blending tones into each other, since the texture is different. To achieve the soft midtones you see here on the fabric, however, the secret is to blend the different shades into each other while the paint is still wet.

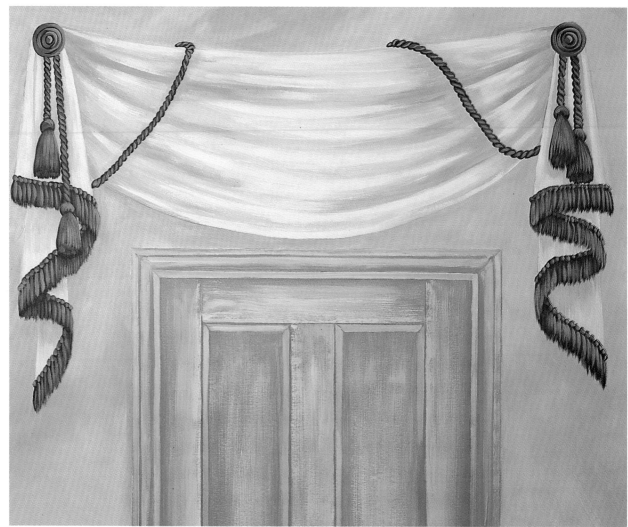

Patterned Fabric Curtain with Tieback

With patterned fabric, the pattern itself can be used to create the effect of folds. Make the pattern 'disappear' behind a deep fold, or hide parts of the motif with shallow folds. You can also mix some cream with the colours of the patterns, and use this to highlight bits of the pattern of the draped or folded fabric. This too will add a three-dimensional effect to what is essentially a study in line.

YOU WILL NEED
Base coat in white
Lining paper (optional)
Watercolour pencils in brown and blue
Vinyl matt emulsion (latex velvet) in cream, dark blue, green and dark beige (fabric)
Vinyl matt emulsion in dark blue, mid blue and cream (trimmings)
Decorator's brush, 5cm (2in) wide
Fitch brush
Artist's brush, size 8

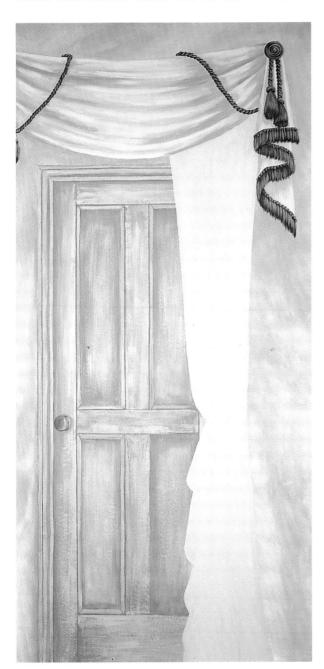

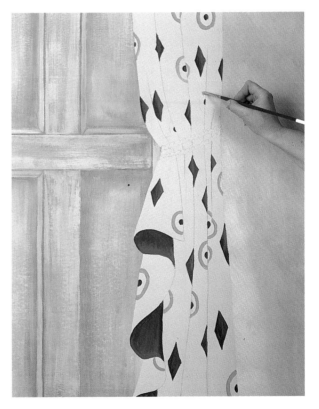

1 With a watercolour pencil, draw the outline of the curtain on the wall/door. Once again, you can experiment with lining paper first if you wish, and even create a template from it. Apply the white base coat with a decorator's brush. Block in the curtain in cream vinyl matt emulsion (latex velvet) using the decorator's brush, and the fitch brush along the edges.

2 With the watercolour pencils, draw lines representing the folds of the fabric, the cord tieback and the principal elements of the design (in this case, the diamonds). If you are using a pattern of your own for the fabric, choose a simple one, such as a design based on simple geometric shapes or lines. Using the artist's brush, block in the blue areas (the lining, which shows in the folds down the leading edge of the curtain, the diamonds and the dots), then draw in the green circles around the blue dots.

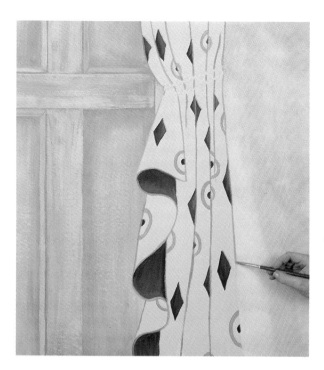

3 With the dark beige, paint the outline of the curtain and the fold lines, using the artist's brush. The lines can vary in thickness.

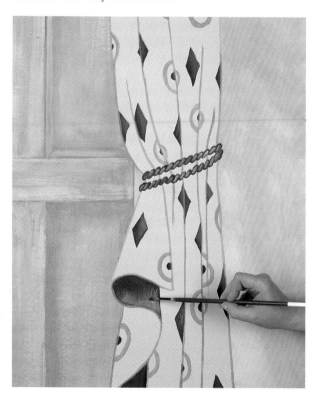

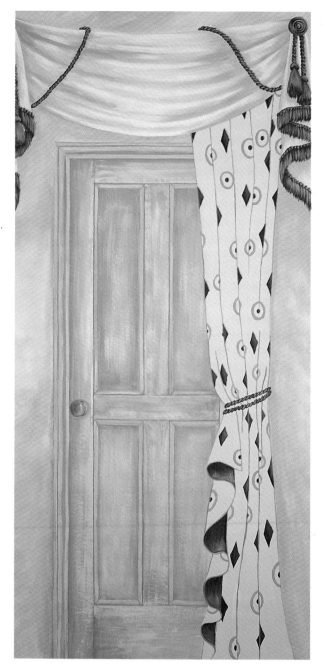

• The two methods of creating three-dimensional effects when painting fabric can be compared here. The plain fabric of the swag relies upon shadows and highlights, while the pattern of the curtain fabric conveys the impression of folds, without the need for much highlighting or shading.

4 Vary the tones and add interest to the curtain by creating highlights on the lining inside the folds. Add cream to the blue paint for this, and apply with the artist's brush. Then, using the same brush, paint the cord tiebacks as for the cording on the swag (see page 51, steps 5–7), using dark blue, mid blue, and cream mixed with the mid blue.

TECHNIQUES AT A GLANCE
Painting the trimmings

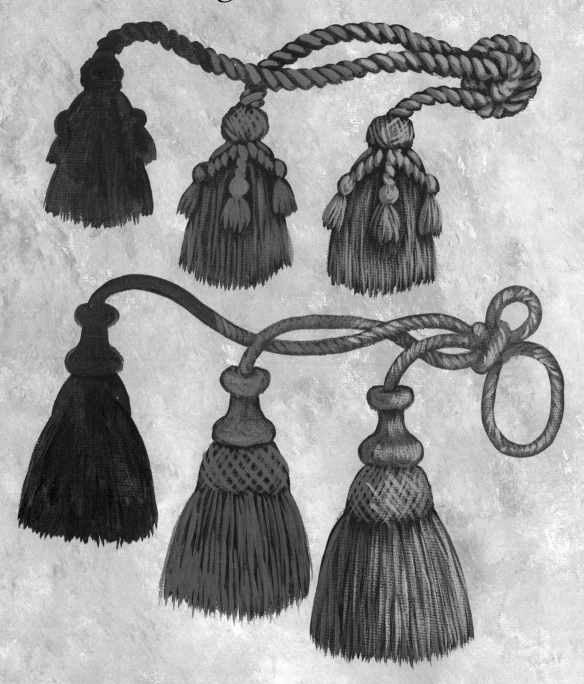

TASSELS

• Fill in the area using the base colours, allowing the brushstrokes to hint at the shape. For each tassel head (the ball at the top), stipple the colour. Use the tip of the brush to create the ends of the fringing on the bottom of each tassel.

• Apply the mid blue using long, thin strokes on the main part of the tassel, and shorter ones on the small tassels. Make a short, fat, S-shaped stroke with the brush to add cord details. With light crisscrossing strokes, add the detail to the tassel top.

• Lighten the colour by adding cream, and apply it with fewer and fewer thin strokes.

CORDS

• You can vary the style of the cord using S-shaped brushstrokes and different colours. Alternating the sizes of the segments also adds variation.

• Use shallow C-shaped strokes and the tip of the brush to create thin highlights emphasizing the curved shapes of the individual segments of cord.

• Knotted cords are painted using the same brushstrokes as for unknotted ones, with C-shaped strokes for the highlights on the knots and ties. Tiebacks for curtains can also be painted in this way, as in the photograph on page 54.

FRINGING

- Fill in the dark base shape, using the brushstrokes to suggest the shape of the subject. Stipple the tassel knots.

- Add some midtone detail by mixing a touch of cream with the base colours.

- Add more cream to the colours and apply this with tiny brushstrokes to create a few pale highlights.

- Fill in the base shape with the dark colours. Stipple the tassel heads and use long brushstrokes for the fringe.

- Add cream to the base colours and paint the midtone detail on the fringing.

- Add more cream and use this to paint a few pale highlights.

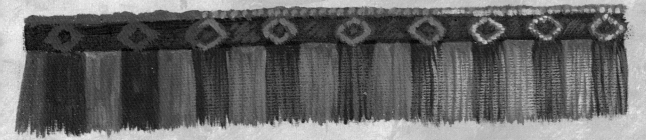

- Fill in the base design with dark tones using the brush to suggest the pattern detail.

- Add cream to these and paint the midtones. Use the point of the brush to create the tiny details of the braid.

- Add more cream to the colours and lightly highlight.

- Fill in the base shape and use a stippling action with the brush to paint the pompons.

- Add cream to the colours and paint the midtones.

- Add more cream to the colours and use these to add highlights to the fringing.

ADDING
PERSPECTIVE

To 'trick the eye', trompe l'oeil creates the illusion of three dimensions on a flat, two-dimensional surface. To do this, it utilizes not only light and shade but also perspective. Perspective is probably the most fundamental aspect of drawing. It exploits the way our brains interpret messages from our eyes. For example, because we know that something in the distance will look smaller than the same thing seen up close, we realize that a picture with, say, a large tree in the foreground and a small tree in the background is depicting two trees of similar size placed a considerable distance apart.

Similarly, we know that in real life two parallel lines do not look parallel when they are stretching away to the horizon; they appear to converge. Perspective drawing makes use of this, showing lines that will converge at a point on the horizon line. Even if the lines do not actually meet, they are drawn at such an angle that they would meet if extended to the horizon line. The viewer interprets these as parallel lines on a three-dimensional shape. The point on the horizon at which the lines converge is known as the vanishing point. Other pairs of parallel lines will have different vanishing points.

The horizon line is always at the viewer's eye level (even in drawings that are not landscapes and have no 'horizon' as such). This eye level can be at any height, depending on whether the viewer is looking up, down or straight at the drawing. Everything above the horizon line is viewed from below, and everything below it is viewed from above. Items that are all at the same height in a drawing will still be seen at different angles – from the left, the right or straight on.

As well as the observation point, you need to decide where the apparent source of light will be, since this affects the positions and shapes of shadows and highlights. If a trompe l'oeil is to go on a wall, cupboard or other permanent site, or if you know where you will be hanging a plaque, it makes sense for the imagined light source to be the same as the light source in real life, such as a window or a lamp.

This chapter's mural – three shelves laden with books and ornaments – offers a good introduction to simple perspective. The shelves could be painted on a plaque, the wall or a door. With their central eye level, they are ideal for the door on a kitchen cupboard. (This central eye level is good for trompe l'oeil shelves, as it is simple and straightforward to draw.)

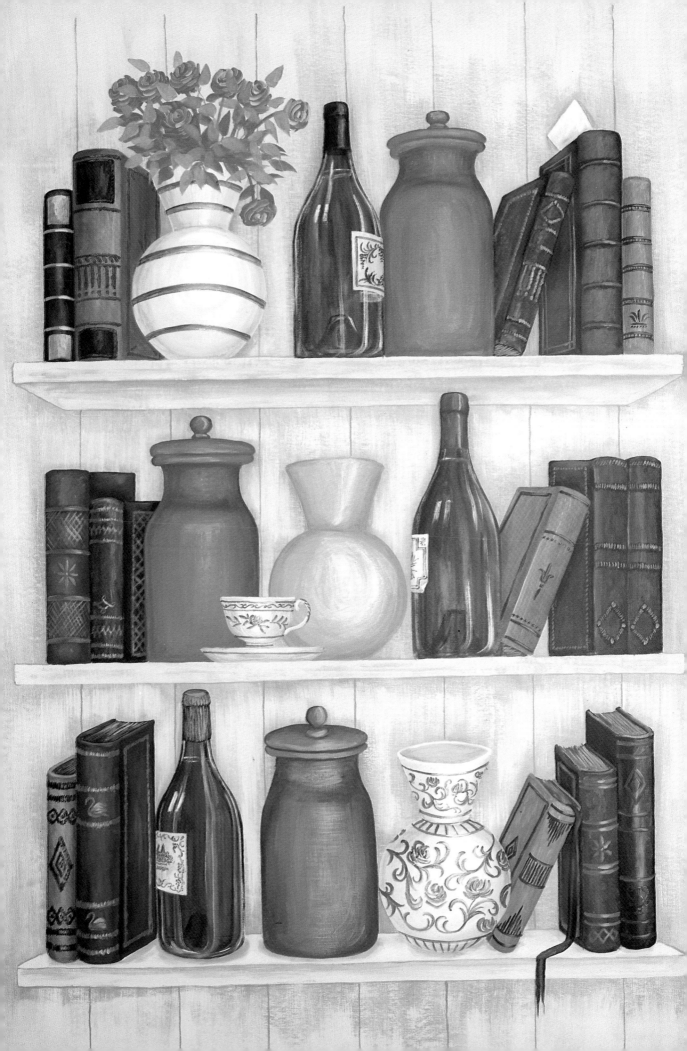

Background and Shelves

Although the details are great fun to do, they are the icing on the cake here. Before you can begin them, you must draw the shelves, plan the positions of the books and ornaments, draw them and then block in the colour.

It's important to spend time on drawing the shelves so that you are sure they are level and the perspective lines are correct (in other words, that they would converge if extended to the 'horizon line' on the middle shelf). You may find that it helps to sketch the shelves, books and ornaments first on a large piece of paper (such as heavy duty lining paper), so that you can plan your composition and experiment as much as you like.

Once you have established the shape of each ornament, use your final sketch to make a template (or use one of the illustrations on pages 69–71 to make a template). For symmetrical objects like these, the template should be for half the shape; after drawing around it, turn it over and draw the other half. This ensures that it is truly symmetrical.

When drawing the composition, initially just draw the spines of the books. You can draw in the perspective lines a little later, after you have planned out the basic elements of the composition. A good guide for the thickness of a book is the width of a ruler, then, for variety, make some of the books a little thinner or thicker.

Instructions are given in this section for painting the shelves and board background, the books, bottles, vases and terracotta jars. The teacup and saucer are painted in the same way as the vases, and the instructions for the miniature roses are on page 41. The ribbon bookmark consists simply of one brushstroke with a highlight added. The technique used for painting the background is also useful for other backgrounds.

YOU WILL NEED
Base coat in white
Vinyl matt emulsion (latex velvet) in dark brown, tan and cream
Acrylic or vinyl matt emulsion in black, white, gold, dark grey, dark brown, chrome green and a range of other colours for books and ornaments, such as terracotta, deep rust orange, ultramarine, dark blue, tan and yellow
Lining paper (optional)
Spirit level (carpenter's level)
Pencil, such as a watercolour pencil
Metre ruler (yardstick)
Decorator's brush, 5cm (2in) wide
Artist's brushes, sizes 8 and 5
Fitch brush
Palette

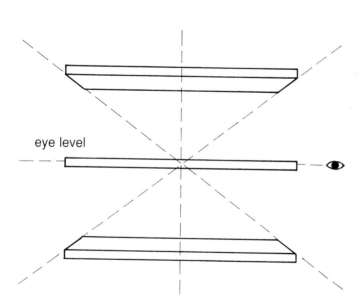

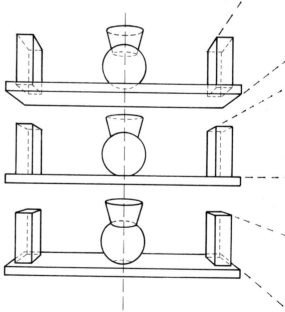

• The middle shelf represents the eye level, so that you are looking up at the top shelf and down at the bottom shelf. The perspective lines, if extended, would meet at a point on the eye-level 'horizon'.

• The observation point is right in the middle – the items that are viewed straight on are in the very centre of the middle shelf. The light source is assumed to be behind the viewer.

1 Using the decorator's brush, paint the surface with the base coat. Draw the front edge of each shelf, using a spirit level (carpenter's level) to ensure that each is level. Using a metre ruler, check that the shelves are the same length, thickness and distance apart. Draw the underside of the top shelf and the top of the lower shelf, making suring that the perspective lines are at the correct angle (see diagram opposite left). If preferred, you can draw the shelves first on lining paper, then transfer this to the surface.

2 Draw the spines of the books on the shelves. Note that the books on the bottom shelf are curved at the base of the spine, and all the books are curved at the top of the spine but in different ways, depending on the shelf. For each ornament, draw a vertical dotted line, which will be at the centre; check that this line is exactly vertical. Make a template for half of each ornament and draw around it.

3 Turn the templates over and draw the other half of each ornament. Draw the perspective lines for the covers of the books (see diagram opposite right). Do not omit the dotted lines on the books and ornaments – these will help you achieve the correct perspective. Draw them faintly so that they won't show through light-coloured paints. (We have made ours a little darker for the purpose of the photograph.)

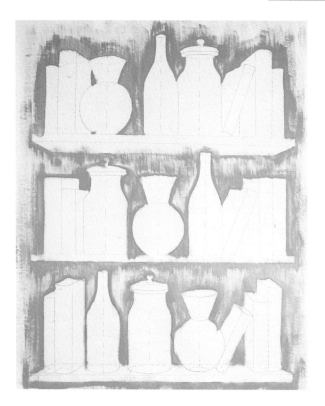

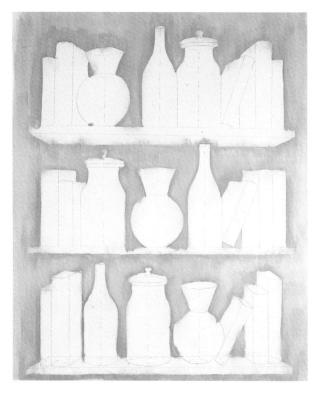

4 With the dark brown emulsion (latex), paint in the shadows around each book, ornament and shelf. Use the no. 8 artist's brush to paint just around the shapes, and then the fitch brush with vertical brushstrokes to give the shadows ragged edges.

5 As the dark brown is drying, apply the tan to the background, again using the fitch brush. Blend it into the dark brown, again using vertical brushstrokes to create ragged edges.

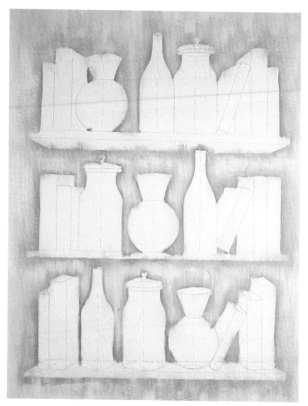

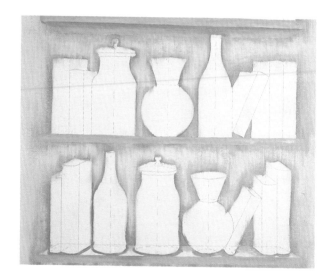

7 Paint the shelves in much the same way as the background, but using horizontal rather than vertical strokes. Start with the dark brown shadows, painting them around the curved bases of the ornaments with the no. 8 artist's brush and shading out from them following the curved shape. The underside of the top shelf should be especially shadowy, whereas the fronts of the shelves have almost no dark brown. While that paint is still wet, blend in the tan midtones using the fitch brush as well as the no. 8 brush.

6 Before the paint has dried, paint in the cream highlights on the background in the same way.

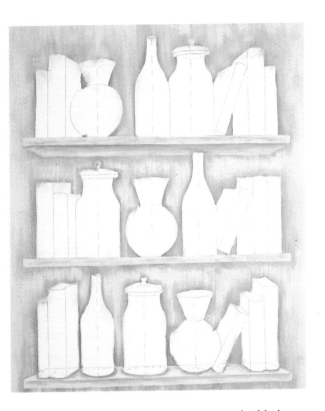

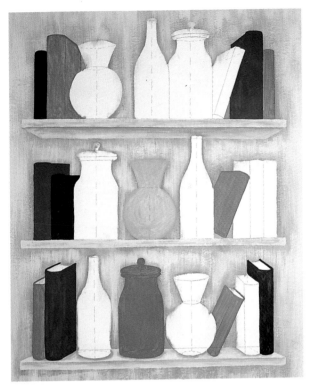

8 Finish the shelves by blending in cream highlights, again using horizontal brushstrokes with the fitch brush. The top of the bottom shelf should be highlighted the most because the light would fall on it more. Use the cream paint undiluted and, as it dries, scuff it with the brush to create a 'woody', textured effect (see page 12, Distressed Finish, step 2).

9 Begin to block in the colours of the books and ornaments using the fitch brush, and the no. 8 artist's brush on the edges. The colours we used were chrome green, ultramarine, deep rust orange, dark brown and black for the books; white and yellow for the vases; terracotta for the storage jars and dark grey for the bottles. Keep checking as you work to ensure that the colours are balanced. Add variety by mixing a little black with some of the colours to create a deeper shade. Don't worry about making the blocked-in colours even and solid, since they will be painted over again when the shadows, highlights and details are added.

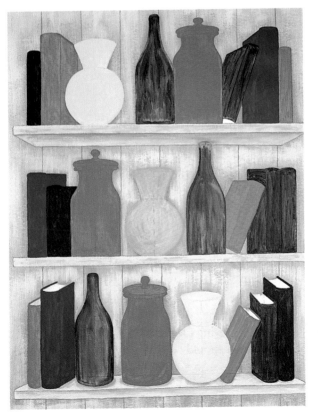

10 When you have finished blocking in the colours, pencil in the lines representing the edges of the wooden boards, using a metre ruler (yardstick). Make sure that they align all the way up. Paint over the lines freehand with dark brown emulsion (latex), using the no. 5 artist's brush – you'll need a steady hand. Now you are ready to add the details to the books and ornaments (see pages 64–68).

Books

Careful detailing will make the books on your trompe l'oeil shelves look surprisingly convincing. This aspect is especially fun, since the spines offer the ideal opportunity to personalize your work with witty titles and names of authors and publishers.

The technique given here for painting the book spines can be used to create a whole shelf of books showing only the spines. You could also adapt the technique to paint a single, personalized book and ornament on a small plaque to give as a gift.

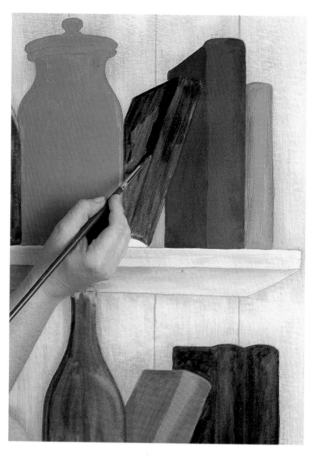

1 Put on your palette one of the colours you used for blocking in the books (see page 63) and dilute it a little with water. Apply this over one of the blocked-in books of that colour. Now mix some black into the diluted colour and use the no. 8 artist's brush to paint this shading onto the drying base coat. Apply it lightly down the spine and also across the spine where the 'embossed' details will go (see step 4). Think about which areas of a real book would be shadowy – such as the back of the book where it is hidden by another leaning against it – and concentrate the shading in those areas.

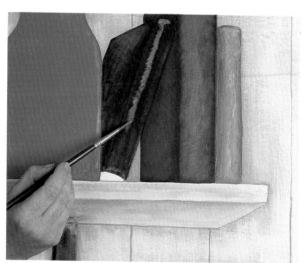

2 Continue working on the same book, since the base coat needs to be wet, or at least damp, to achieve good shading and highlighting. On your palette add some cream emulsion (latex) to the diluted colour. Using the no. 8 artist's brush, paint this highlighting down the spine, roughly in the centre where the light would fall. Use the same paint and brush to create a dappled effect on parts of the book, giving it an aged appearance.

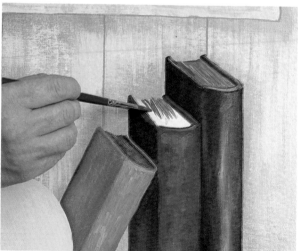

3 Repeat steps 1 and 2 on the other books. Now mix some tan emulsion (latex) with black or dark brown and use the point of the no. 5 artist's brush to paint streaks to look like pages on the top of some of the books. Add some tan or cream to the paint, and paint in some more streaks.

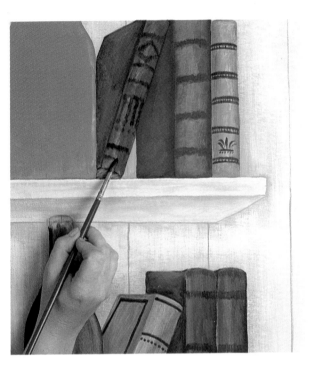

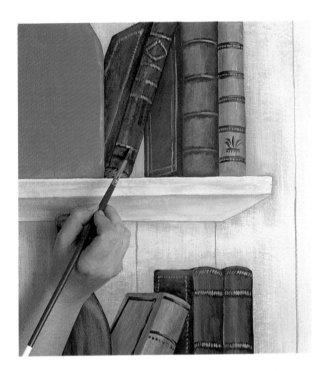

4 With a watercolour pencil, very lightly sketch in the 'embossed' details following the curved lines of the tops of the books. Using the no. 5 artist's brush, paint over the pencilled details with black or your darkest shadow colour for each book. The 'embossed' detail can be painted on all of the books at the same time, since the paint does not need to be wet to put on the highlights.

5 Still using the no. 5 artist's brush, overpaint the details with a lighter colour in order to create the highlights. If you are using gold acrylic, first mix a little dark brown or black with it and paint this over the detail, before finishing with a highlight here and there using the gold on its own. When deciding what details to highlight, think about which ones would catch the light.

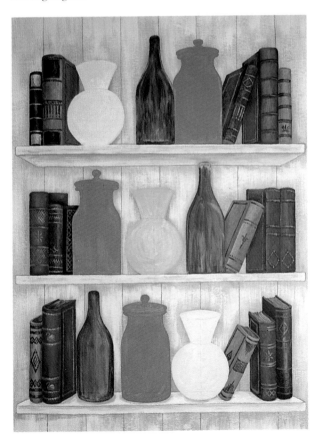

6 Other books can be highlighted in the same way using tan mixed with black, followed by tan mixed with cream. Some can be left with only black detailing highlighted with a little dark grey.

Bottles

The technique of painting glass is far simpler than it looks. The paint is applied in a wash, then, while it is still wet, other lines are blended in across the bottle. Because glass reflects light, adding a streak of colour used on an adjacent object often looks very realistic.

After creating a subtle blend of colours on the bottle, ranging from black to green plus any reflective colours you have added, all you need to add are some highlights. Start with a watery white,

then add a few highlights using thicker white where light would fall on the bottle. Although these white details are not outlines as such, they do define the shape you are painting because they follow the shape of the bottle.

For other glass, whether plain or coloured, and whatever the shape, the principle is the same. However, plain glass has a see-through quality as well and so should include some of the background colours already used.

1 Create the effect of glass by diluting cream paint and green paint with water and blending them into the darker base you blocked in (see page 63). Use sweeping strokes of the no. 8 artist's brush. Dilute some white with water and, still using the no. 8 brush, add a few wide, watery brushstrokes as highlights, following the shape of the bottle.

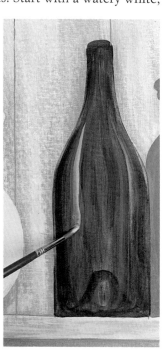

2 Use a little of the diluted white and the no. 8 brush to create a liquid level in the neck of the bottle, lightly softening it with the brush. Now add a few small, strong highlights with undiluted white.

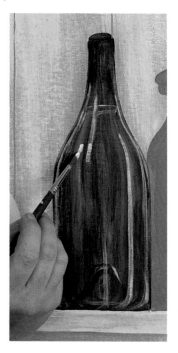

3 Using the no. 8 brush and dark brown or black, paint in the bottle top. With this colour still on the brush, pick up a little white and use this to paint on the label. Continue to pick up white on your brush, a little at a time, and highlight the label with it.

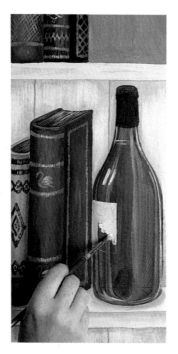

4 To highlight the bottle top, mix gold with dark brown and apply this with the no. 5 artist's brush. Now apply pure gold over this. Decorate the wine label by drawing in the design lightly with watercolour pencil and then painting over it with the no. 5 brush.

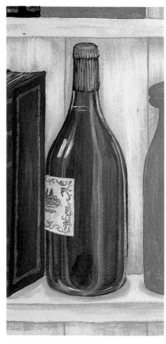

Vases

The steps show the blue and white vase with the scroll pattern, but the blue and white striped vase is painted using the same technique. The yellow vase is painted in the same way too, simply using yellow instead of cream and omitting the patterning. And although the cup and saucer are different shapes from the vases, the painting techniques are the same.

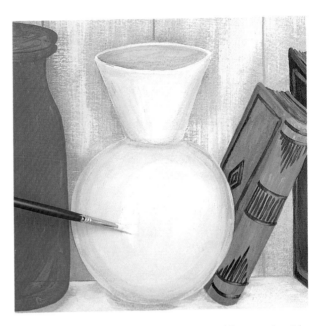

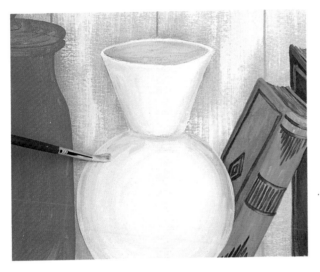

1 Mix a little black or dark brown into the paint you used when blocking in the base colour (see page 63). With the no. 8 artist's brush, use it to shade around the edges and inside the rim, following the shape of the vase. As you work towards the centre, use less black or dark brown and more of the base colour.

2 Add some cream paint to the base colour and, with the no. 8 artist's brush, use this to highlight the centre of the vase, again following the shape of the vase with the brushstrokes.

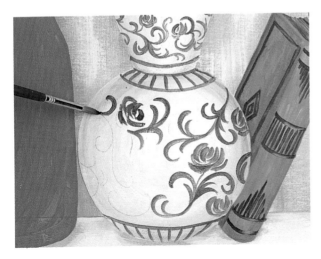

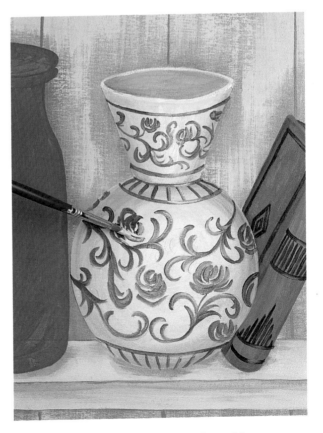

3 If desired, lightly draw the pattern onto the vase with watercolour pencil, or paint it on freehand. Use the no. 5 brush and dark blue paint to apply the scroll design (or the no. 8 brush for the stripes), taking into account the shape of the vase and the perspective.

4 Add some cream to the blue and use this to highlight the pattern when painting the design in the centre of the vase.

Storage Jars

As always, shading is the key to achieving the rounded shape of these storage jars. The colour of the terracotta works well in a composition, but you can use the same technique for pots in other colours, mixing dark brown with the base colour for shadows and cream with the base colour for highlights.

1 Mix dark brown with the base colour you used to block in the jar (see page 63). Use this and the no. 8 artist's brush to blend in shading around the edges of the lid, the knob on the lid and the jar.

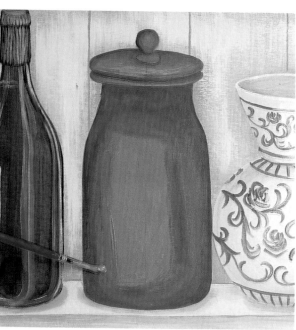

2 As you move towards the centre, use more base colour and less dark brown in the mix. Blend in the edges to avoid any hard lines.

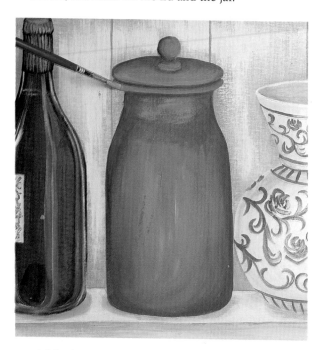

3 Add a little cream to the base colour and, with the artist's brush, highlight the jar where it would catch the light.

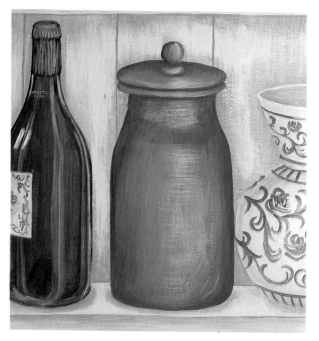

4 Add more cream to the base colour, and paint on the strongest highlights, again with the no. 8 brush.

Alternative Containers

Here is a selection of containers to use in your own trompe l'oeil compositions. Either use them this size or enlarge them on a photocopier. If you wish to make them very large, use the technique of drawing one side and then using a tracing of it as a template for the other side (see page 140) to make sure that it is symmetrical. Use the techniques covered throughout this book for blocking in the base colour and then applying the midtones and the highlights.

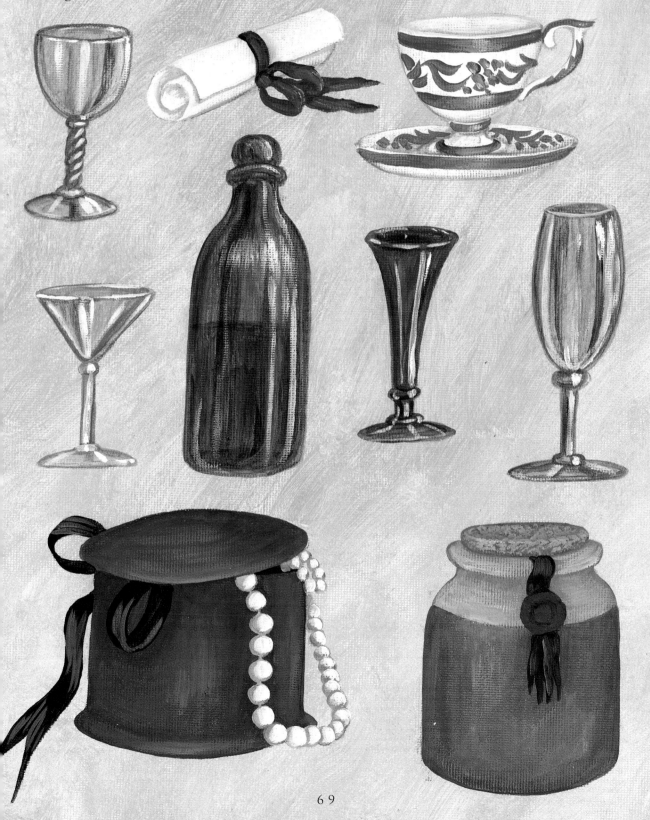

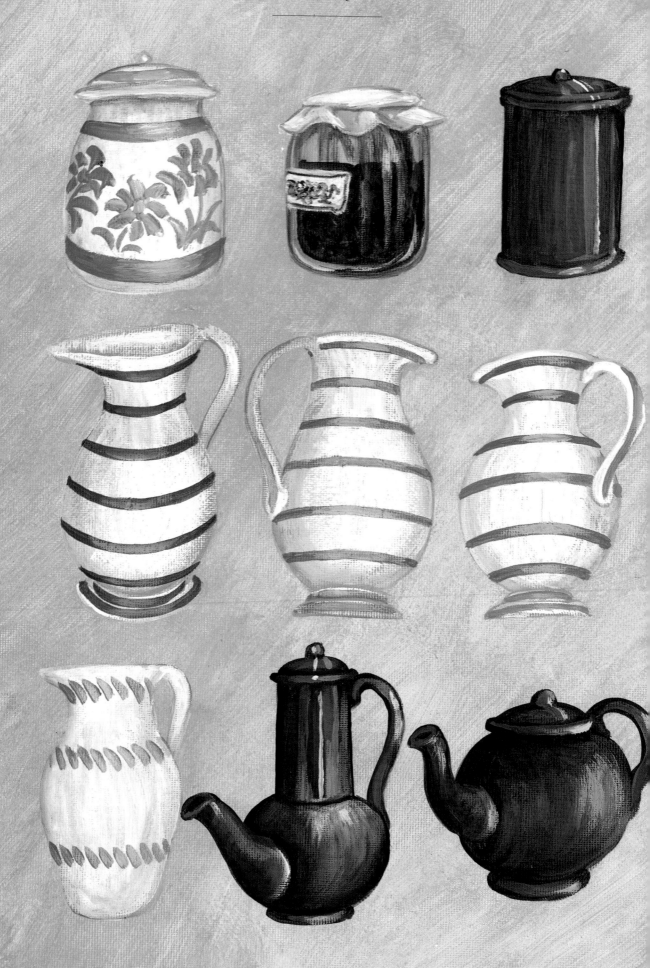

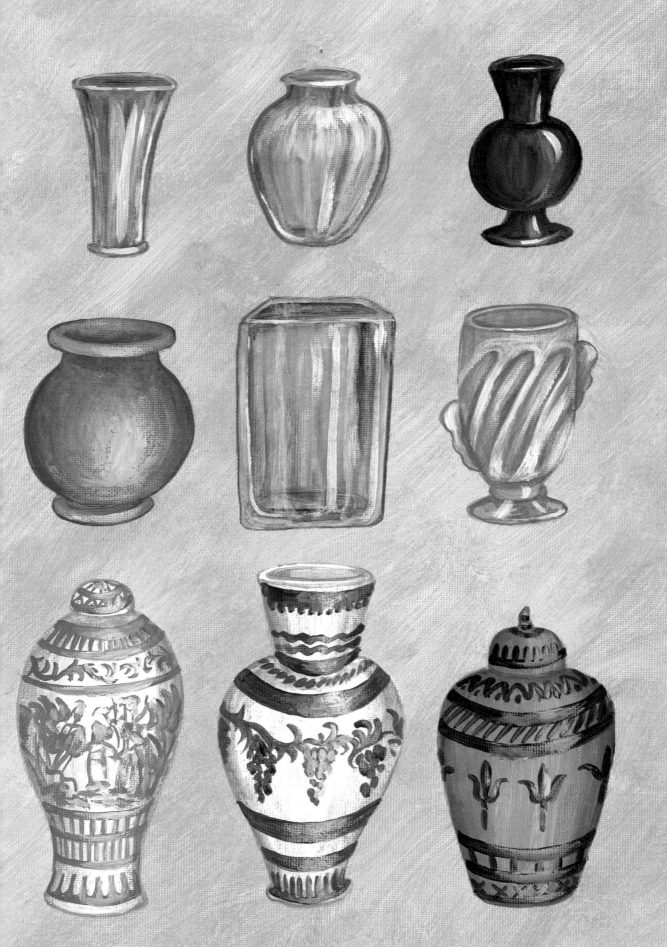

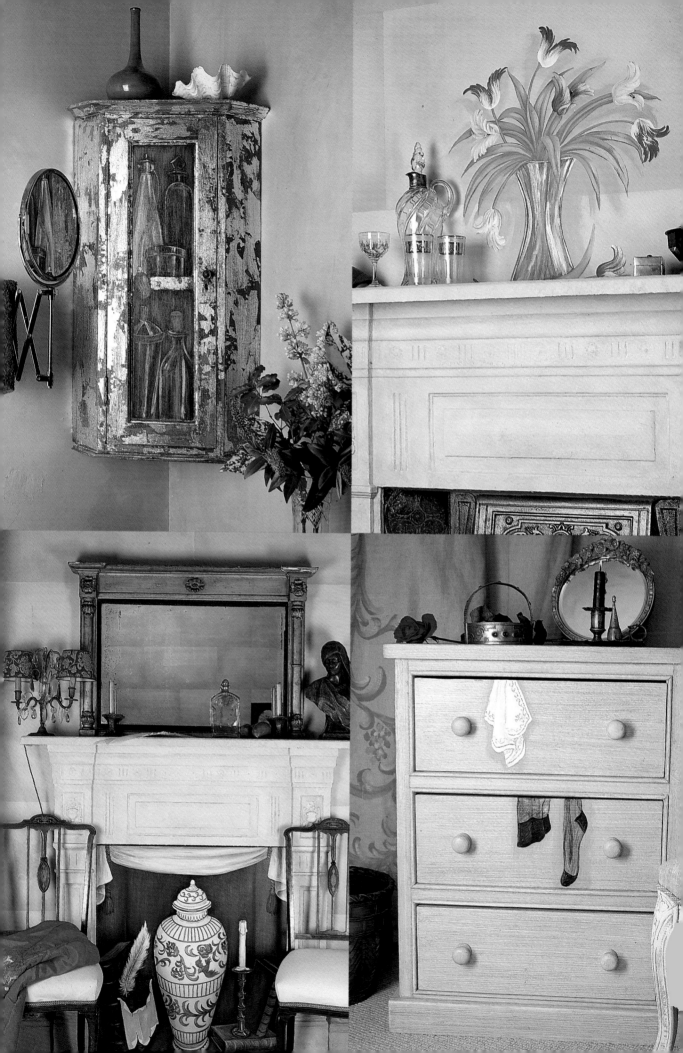

THE
PROJECTS

Now that you have learned how to paint various basic trompe l'oeil subjects, such as stonework, panelling, plain and patterned fabrics, trimmings, books and many different ornaments, you can use these techniques in a variety of projects. There is no need for them to be combined with the same techniques as in the first part of this book, as you will see from the projects included here. For example, trompe l'oeil foliage looks wonderful with faux stonework; faux fabric complements trompe l'oeil panelling; and trompe l'oeil knotted cord combines well with painted flowers.

The projects suggest particular ways of using these compositions, including on plaques, cupboards, walls, screens and other furniture. But the beauty of trompe l'oeil is that everything is interchangeable – for example, we show a fabric swag and festoons of flowers encircling a hat box, but they could equally well be used as a border running along a picture rail.

Every project contains comprehensive step-by-step instructions and photographs, and also a reminder of which techniques are involved. Complementing the photos for each project are illustrations highlighting the build-up of colour for the motifs, so that you can see at a glance exactly how the trompe l'oeil effects are created.

HAT BOX

Jazz up a large hat box or other storage box by painting decorative motifs on it. If you base your design on something in the room, you can coordinate the box with your decor. The design used here was inspired by the chintz fabric of the room's curtains. So long as the colours are fairly close to the original, a simple interpretation of the design will usually suffice.

Recycle an old hat box or other storage box, or buy a new one – the preparation and painting techniques are much the same for either. The same technique could be used to paint a decorative frieze on the walls of the room.

This design consists of three swags encircling the hat box – a perfect arrangement for a round box with deep sides. The swag is intertwined with full-blown roses and tasselled cord. The sides of the lid echo this in a simpler way, with rosebuds and leaves entwined with draped and knotted cord. On the top of the lid, the swags are omitted and the flower heads and leaves are combined with cord and tassels, all radiating out from the centre of this circular motif.

It is easier to paint the top of the lid separately, but the swags going around the sides of the hat box need to be painted all at once so that there will not be any 'tidemarks' where wet paint overlaps dry paint. You could paint the sides of the lid at the same time, as in our photographs, or separately, as preferred.

The techniques used here are covered in detail on pages 41–42 (Miniature Roses) and pages 50–52 (Plain Fabric Swag and Trimmings).

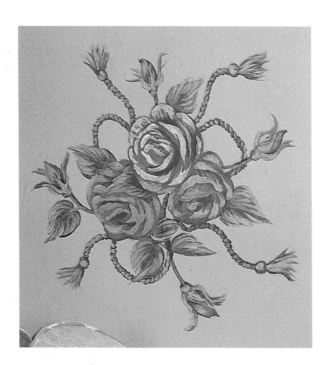

YOU WILL NEED
Hat box
Vinyl matt emulsion (latex velvet) in cream, duck-egg
 blue, dark green, deep rose red, dark and light green
Watercolour pencils in green and red
Fine sandpaper
Palette
Decorator's brush, 5cm (2in) wide
Artist's brushes, sizes 5 and 8

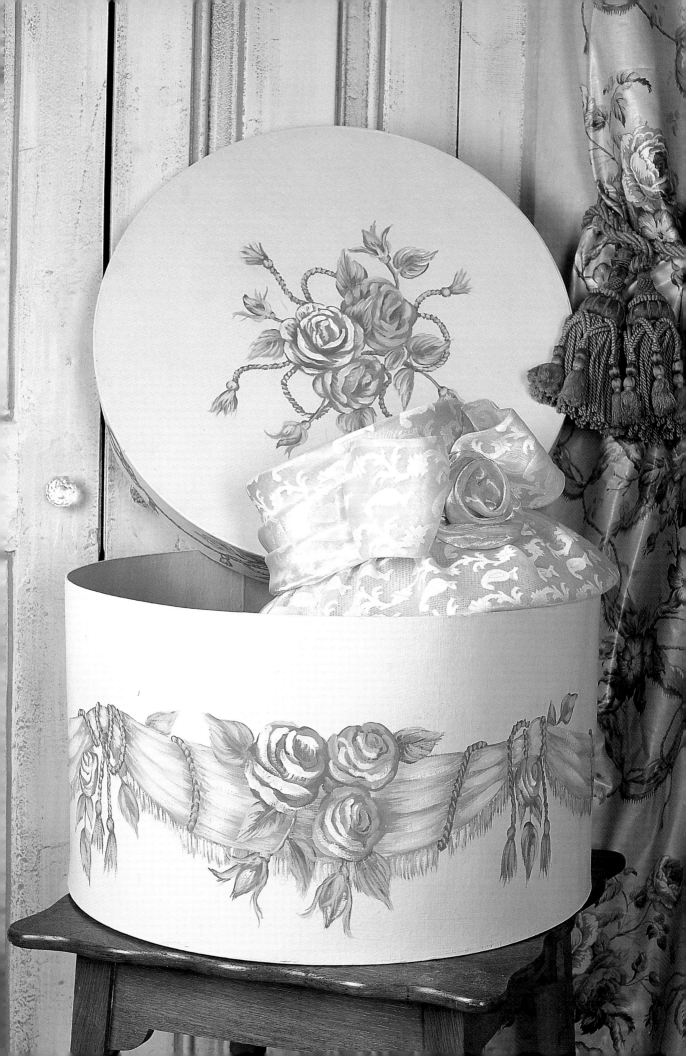

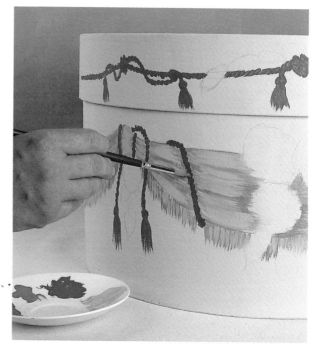

1 Make sure that the hat box is clean and free of dust. If you are painting an already painted surface, lightly sand it down with fine sandpaper. Using the decorator's brush, paint the box and lid with cream vinyl matt emulsion (latex velvet) on the outside and duck-egg blue on the inside. Allow to dry. (Don't worry if the cardboard 'bubbles' initially while the paint is wet – it will dry out and flatten.)

2 Divide the distance around the sides of the box and lid into three equal segments. On a piece of paper as wide as one segment, draw a design for the box and another for the lid that will fit exactly into one segment. Transfer the design to the box and lid (see page 140), butting up the design at the edges of each segment so that it flows smoothly all the way around the box, with no gaps. Now go over the lines with watercolour pencil.

3 Mix the dark green paint with the duck-egg blue. With the no. 8 artist's brush, use this colour to block in the shadows and folds of the fabric swag, following the lines of the fabric. Also paint the fringe. Do this all the way around the box.

4 Fill in the rest of each swag with the duck-egg blue, using the no. 5 brush. Highlight the edge of the fringe with blue at the same time.

5 Block in the loops of cord and tassels in deep rose red around the box, using the no. 8 artist's brush to draw the individual segments of the cord. Add fringed tassels at the cord ends, using the point of the brush. Repeat for the sides of the lid.

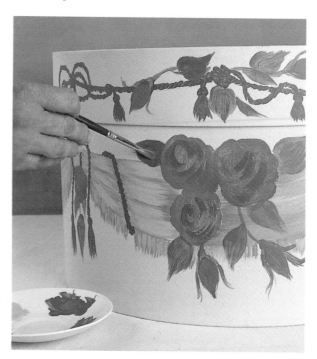

6 Now block in the flowers and foliage on the box and lid sides with the no. 8 brush, using deep rose red for the flower heads and buds, and dark green for the leaves and bud detail. To create the half-moon shapes of the rose petals, use sweeping strokes of the brush.

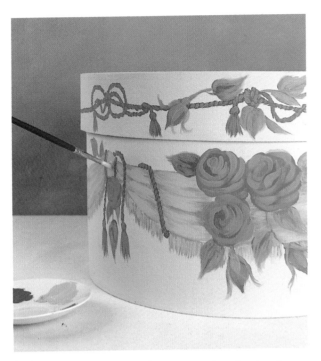

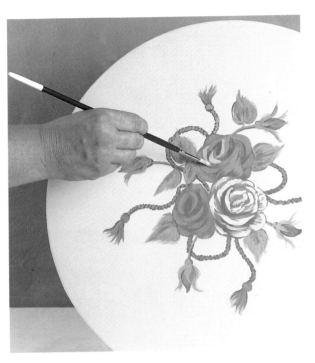

7 Mix cream with the deep rose red and paint the midtones of the roses with the no. 8 brush, still using half-moon shapes for the roses. Add the midtones of the cord and tassels with the same colour and the same brush. Add the leaf midtones using the light green. Mix cream with the duck-egg blue, and add midtones to the folds of the fabric and the fringe using the no. 5 brush.

9 For the top of the lid, repeat the procedure of first outlining the design with the watercolour pencils, next blocking in the leaves and flower heads with the darkest colours, then adding midtones with a finer brush and finally painting in the highlights to create a three-dimensional effect.

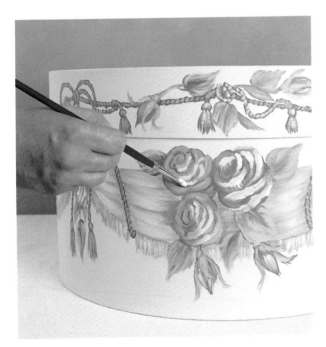

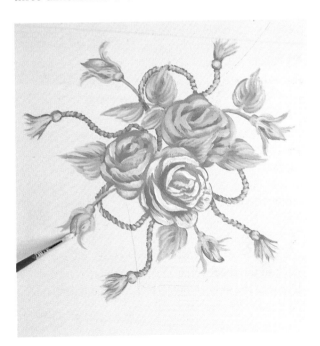

8 Add more cream to the colours used in the previous step, and paint in highlights using the no. 5 brush, or careful strokes of the no. 8 brush. Highlight some roses more than others to add variety.

10 When you have completed the highlighting, check the composition for balance and gaps. Add further detail where required.

TECHNIQUES AT A GLANCE
Painting the hat-box motifs

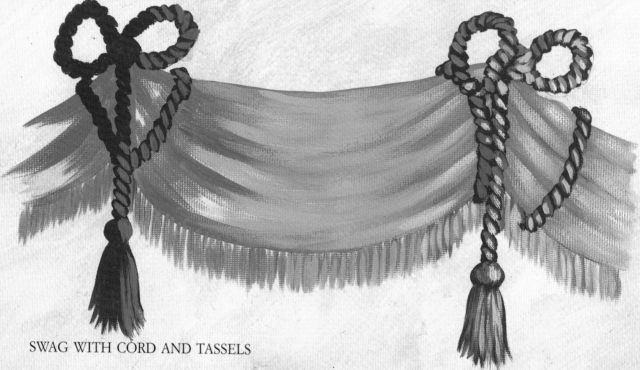

SWAG WITH CORD AND TASSELS

• Block in the cord and tassels using deep rose red, and the folds and fringed edge of the swag using dark green mixed with duck-egg blue.

• Mix cream into the deep rose red and add cord and tassel midtones. Fill in the rest of the swag with duck-egg blue, softening into the already painted shadowy folds.

• Add more cream to the deep rose red, then paint in fine highlights on the cord and tassels. Add cream to the duck-egg blue, and paint a few highlights to the fabric folds and the fringed edge.

ROSES ON SIDE OF BOX

• Paint the flower heads and buds in deep rose red. Block in the leaves and bud details in dark green.

• Add cream to the deep rose red and paint in the midtones of the flower heads. Use light green for the leaf midtones.

• Add some cream to the light green and more cream to the deep rose red, and use for highlighting the leaves and flower heads.

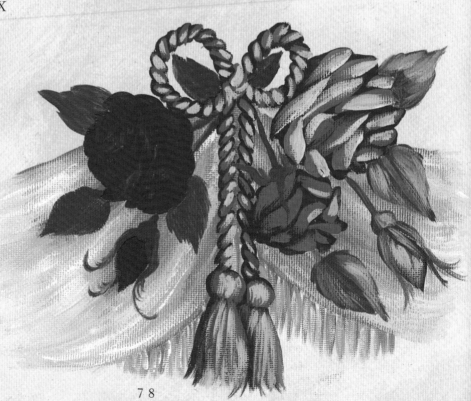

ROSES ON TOP OF LID

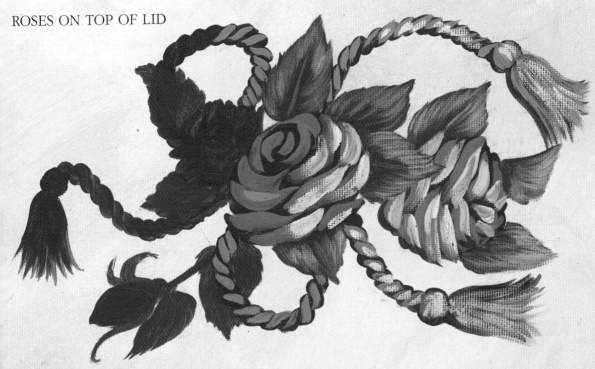

• Paint the roses on the lid in the same way as those on the side of the box, starting by blocking in the roses and buds in deep rose red, and the leaves and bud detail in dark green.

• Paint the midtones using the deep rose red mixed with cream for the flowers and buds, and light green for the leaves.

• Finally, highlight the leaves with light green mixed with cream, and the flowers and buds with deep rose red mixed with more cream.

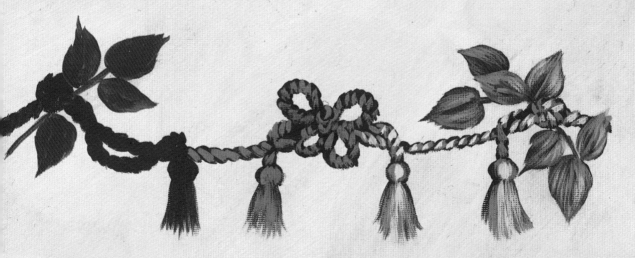

BORDER ON SIDE OF LID

• This is painted just like the swag on the box. First block in the cord and tassels and the rosebuds using deep rose red, and block in the leaves and bud detail using dark green.

• Add midtones to the cord and tassels and the rosebuds using the deep rose red mixed with cream, and to the leaves using light green.

• Highlight the cord and tassels and the rosebuds using deep rose red mixed with more cream, and the leaves using light green mixed with cream.

VASE
OF TULIPS

The vase of flowers shown here has been painted on a chimneybreast just above the mantelpiece so that it appears to be sitting on the mantelpiece itself. The top of a radiator cover would be another suitable site, particularly as real flowers would not last long there.

Another approach would be to depict the vase sitting on a trompe l'oeil shelf, like the one on page 36, or paint it at the back of a work surface. Alternatively, incorporate the vase in a larger trompe l'oeil composition, in which it is one of many different objects arranged on shelves.

The wall shown here has been colourwashed but a flat painted wall or wallpaper would also be suitable. The techniques used for painting the vase are explained in detail on page 66 (Bottles).

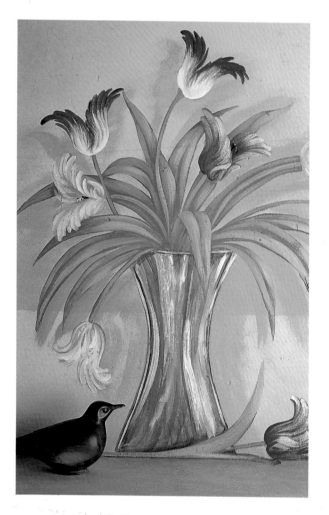

YOU WILL NEED
Vinyl matt emulsion (latex velvet) in cream, dark
 green, light green, white and black
Acrylic paints in white, crimson, cadmium yellow and
 raw umber
Watercolour pencils in grey, green, yellow and red
Palette
Fitch brush
Artist's brushes, sizes 8 and 5

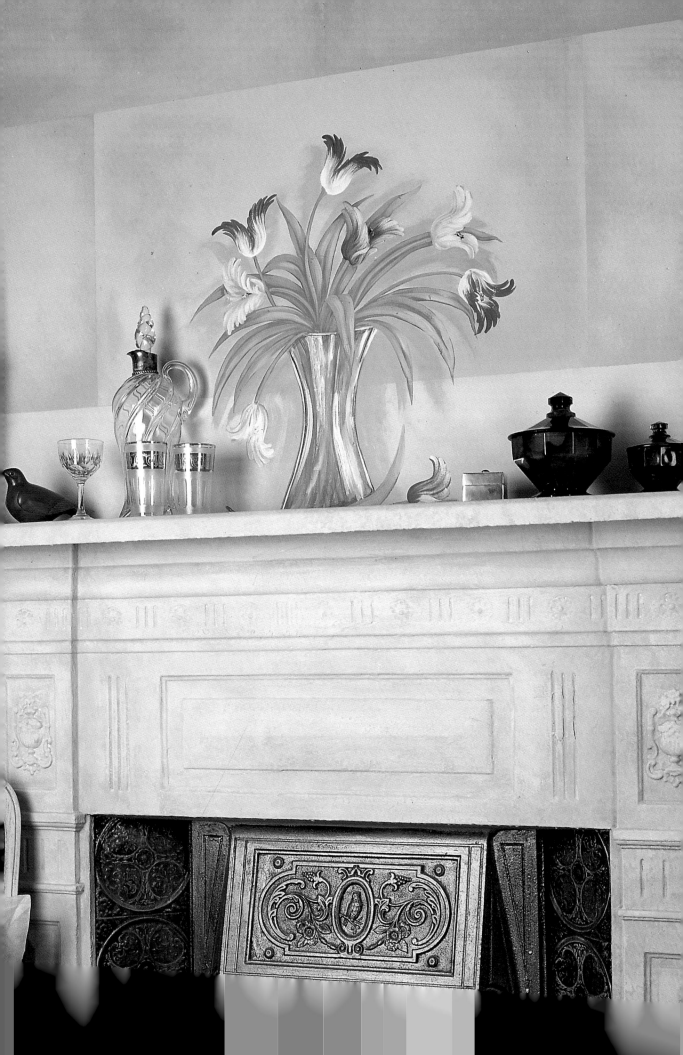

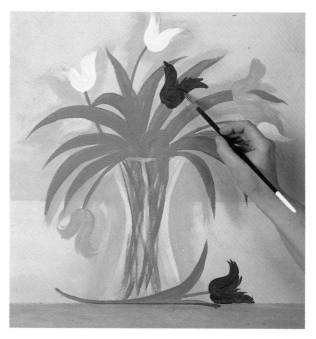

1 Using the grey and green watercolour pencils, lightly sketch the vase and tulip stems and leaves onto the wall. Create shadows around the edges by mixing a little cream emulsion (latex) with raw umber acrylic paint, dabbing a fitch brush in this, then painting lightly around the pencilled sketch. Blend the painted shadows into the wall colour with the fitch. Now draw the flower heads using the yellow and red pencils.

2 Dilute some of the white acrylic paint with water, and paint the vase, using the no. 8 brush. Add more water to the paint to make it translucent, and paint this on, following the shape of the vase.

3 Using the no. 8 brush, block in the leaves and stems in dark green emulsion and some of the tulip heads in crimson acrylic paint. Add raw umber to a little of the yellow, and use this to block in the yellow tulips. For the red-and-white tulips, just block in the white areas for the moment. Add a little raw umber to some of the white paint, and shade the edges of the white tulips.

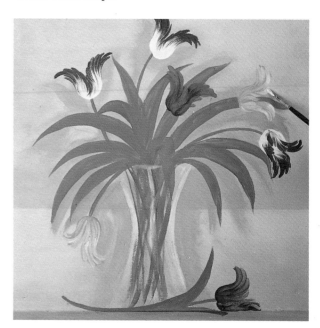

4 Pick up a little red on the same brush. Using the point of the brush, stroke the red into the white, starting at the tips of the petals and working downwards. Add a little white to the crimson acrylics, and paint in some streaky midtones on the crimson tulips in the same way. Use the yellow to add midtones to the other tulips.

5 Using the no. 5 brush, paint in black stamen details
for the flowers on which they would be visible.

6 Add white to the yellow, and more white to the
crimson, and paint highlights on the flower tips
using the no. 5 brush.

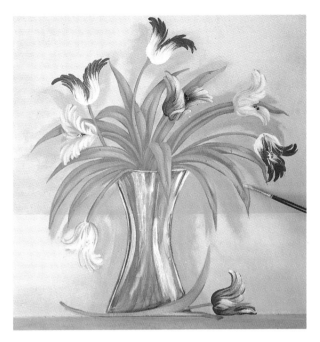

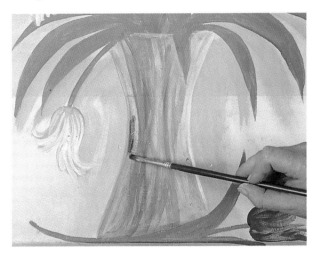

7 Add white and some water to the black paint to
make a watery grey. Paint this wash over the vase,
using the no. 8 brush.

9 Finally, mix light green and dark green, and add
midtones to the leaves with the no. 8 brush, and
then highlight the leaf edges and the stems with light
green, using the no. 5 brush. Mix water with white and
highlight the vase, using the no. 5 brush.

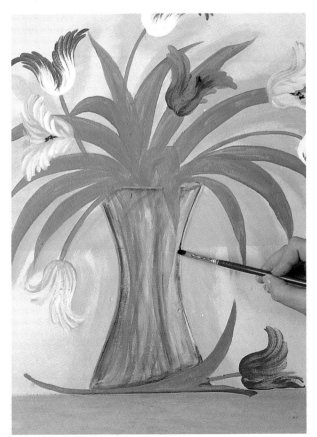

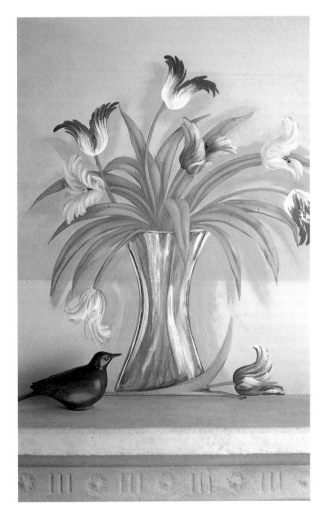

8 Add a little extra black to the wash for shadows,
following the shape of the vase as you paint them
on with the no. 8 brush.

TECHNIQUES AT A GLANCE
Painting the tulips and vase

SINGLE-COLOUR TULIPS

• Block in the colour of the tulips, using either yellow mixed with raw umber, or crimson.

• Paint streaky midtones in either yellow, or crimson mixed with white. Add black stamens.

• Add more white to the yellow and crimson and use these to highlight the tips of the flowers.

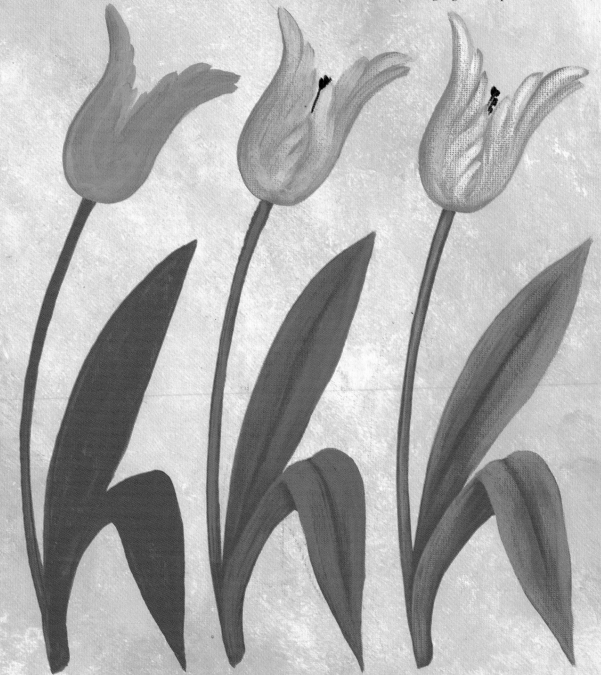

• Using dark green, block in the leaves and stems.

• Mix some light green into the dark green, and add midtones to the leaves.

• Highlight the leaf edges and stems with light green.

RED-AND-WHITE TULIPS

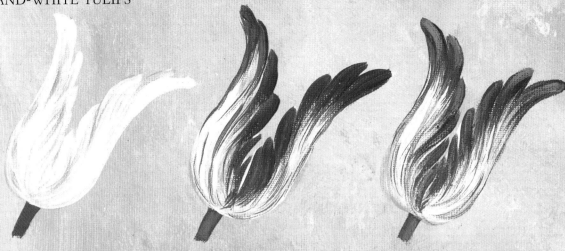

• Paint the flowers initially in white. Add raw umber to the white to shade the edges.

• Paint the tips of the petals red, streaking the colour into the white.

• Add white to the red and highlight the tips of the petals.

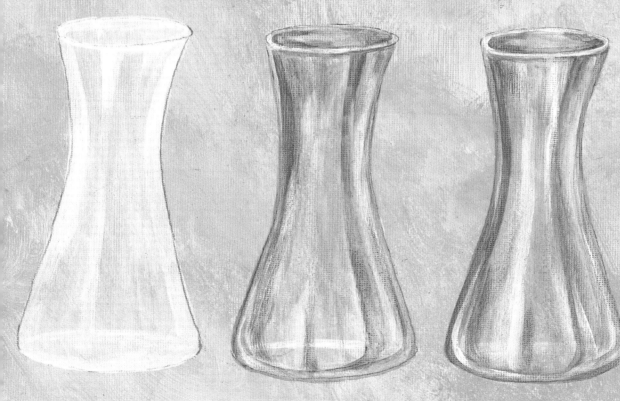

GLASS VASE

• Paint the vase with a wash of white, adding more water to make it translucent in places.

• Mix black and white to make grey, then add water. Paint this wash over the vase. Add a little extra black, and use for shadows.

• Add a little water to the white, and highlight the vase.

SPRIGS OF HERBS

Trompe l'oeil sprigs of dried herbs look wonderful 'hanging' on a kitchen wall and are quick and easy to paint. Three bunches are shown here – rosemary (top), sage (centre) and French lavender (bottom) – but just one bunch would look good too. The size and shape will depend on the space where you are painting it. Although the herbs in the photograph are shown on a colour-washed wall, they could also be done on a flat painted surface or on wallpaper.

The techniques used here for painting the herbs are covered in detail on pages 42–43 (French Lavender). The string that the bunches are tied to is painted using the same technique as the cord and trimming on pages 51–52.

The soft, dusty, faded colours used here are ideal for creating dried herbs, but you could adapt the idea to depict fresh herbs, simply by mixing less cream paint with the colours. Similarly, the project could be adapted to included dried flowers instead of herbs – simply follow the techniques for fresh flowers (see pages 38 and 41) but add generous amounts of cream paint to the colours.

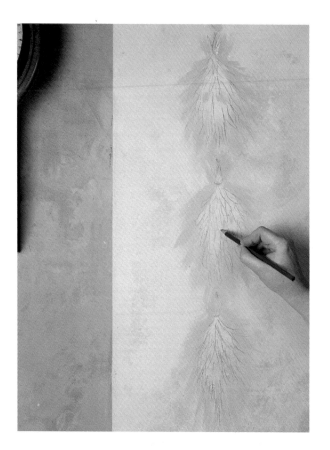

YOU WILL NEED
Vinyl matt emulsion (latex velvet) in dark green, light green and cream
Acrylic paint in raw umber
Watercolour pencil in green
Matt acrylic varnish (optional)
Palette
Fitch brush
Artist's brushes, sizes 5 and 8
Varnishing brush, 5cm (2in) wide (optional)

1 Using the watercolour pencil, lightly sketch the shapes of the herb bunches. If you are painting onto wallpaper, mix raw umber with a little water, and paint the shadows around the edges with this, using a fitch brush. If your wall is painted or colourwashed and you still have some of the paint that was used, mix it with raw umber and paint the shadows around the edges with that. If you don't have any of the paint left, use raw umber mixed with a little cream emulsion (latex) to create these shadows, then wet the fitch and use it with hardly any paint to soften the shadows into the wall colour. Now fill in more detail with the pencil.

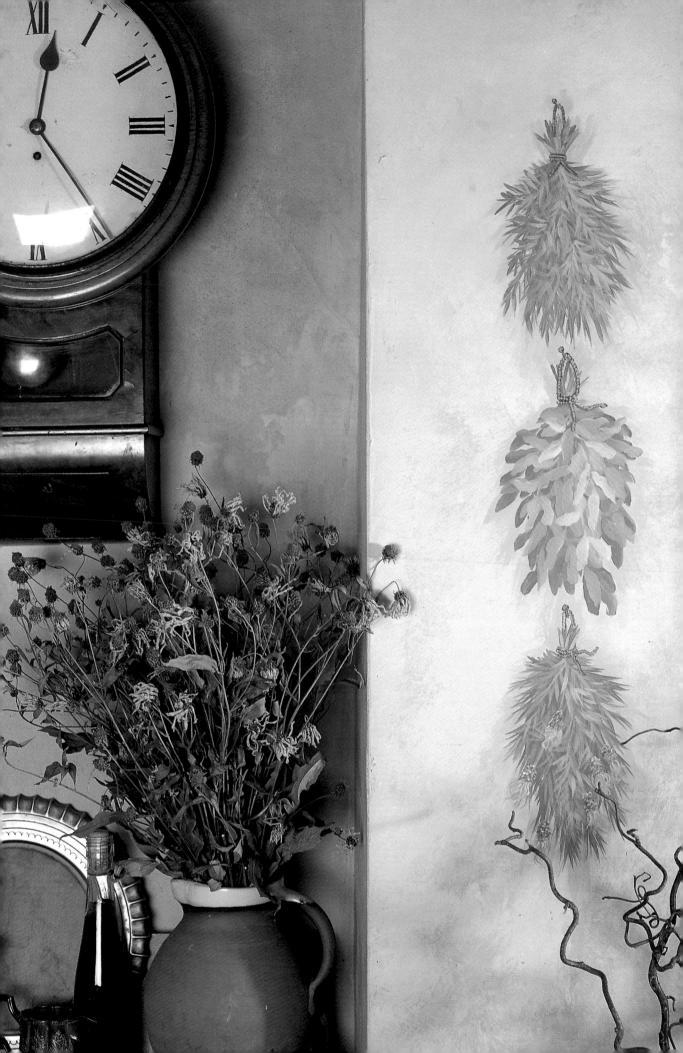

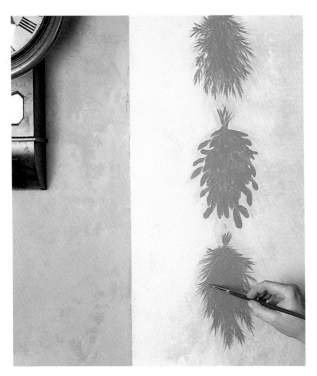

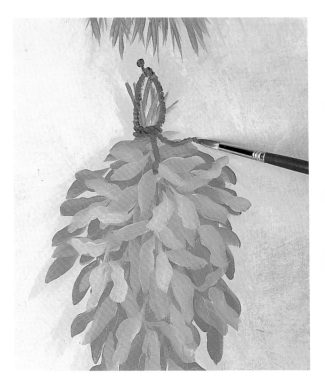

2 With the no. 8 artist's brush, block in the bunches of herbs in dark green. Use the same colour to paint leaves extending down from each central mass of green. With both artist's brushes, paint dark green stems at the top of each bunch.

4 For the string, mix some cream into the raw umber and apply it with the no. 8 brush, using the point of the brush to create the individual sections. Now paint the nail using raw umber but this time without adding any cream.

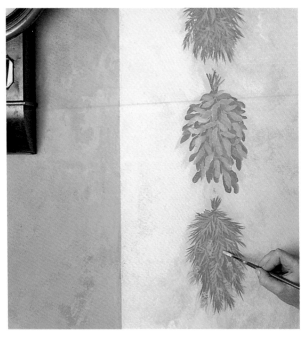

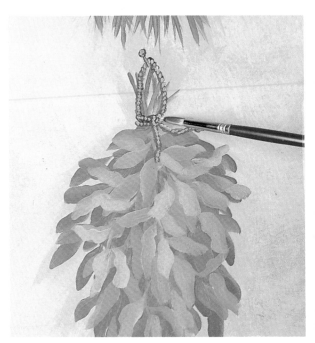

3 With the no. 5 brush, paint in the lighter leaves on top of the green bunches. Start with the light green, and gradually add tiny amounts of the cream to it to produce the range of dusty, creamy greens associated with dried herbs. The technique is the same as for the French lavender foliage (pages 42–3), but with more cream added.

5 Add more cream to the cream-and-umber mix and use this to highlight the string, applying it with the no. 5 brush. Highlight the head of the nail with a tiny amount of cream using the same brush.

6 If you are working on a kitchen wall, protect the paint with one or two coats of matt acrylic varnish.

TECHNIQUES AT A GLANCE
Painting the sprigs of herbs

SAGE

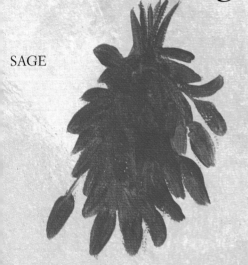
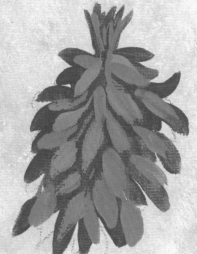
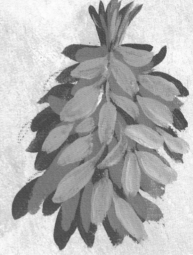

- Block in the leaves in dark green.

- Paint the midtones in light green mixed with a little cream.

- Paint the highlights in a very creamy light green.

ROSEMARY

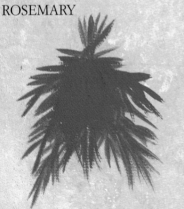
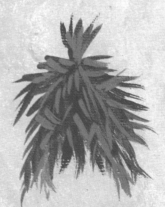
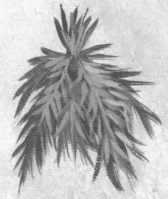

- Block in the leaves in dark green.

- Paint the midtones in light green mixed with a little cream.

- Paint the highlights in a very creamy light green.

STRINGS AND NAILS

- Paint the strings in raw umber mixed with cream, and the nails in raw umber.

- Highlight the strings with raw umber mixed with more cream.

- Highlight the nails with cream.

CHEST OF DRAWERS

Trompe l'oeil often includes visual jokes, and thinking of appropriate images is part of the fun. Here, a stocking and a handkerchief appear to be trapped in the drawers while a silver-backed mirror, a long-stemmed red rose, a pewter plate and a diary are strewn around the top of the chest. You could depict the same objects in your project or substitute different personal items of your own.

All of these items except for the stocking are painted using techniques covered in the first part of the book. The handkerchief is painted like fabric (pages 50–54), the diary in the same way as books (pages 64–5), the rose like the miniature roses (pages 41–42), except that this rose has shading on the leaves, and the silver-backed mirror and pewter plate like vases (page 67) but with extra highlighting. The stocking is unique and done in the special way described here.

The easiest way to approach this project is to draw the items first on paper, then make templates. Experiment with different arrangements of the templates before lightly drawing around them on the chest of drawers.

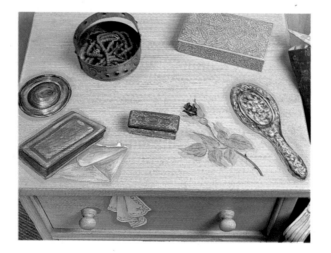

YOU WILL NEED
Acrylic undercoat primer in white (for base coat)
Clear acrylic scumble glaze (for painting chest)
Vinyl matt emulsion (latex velvet) in tan, black, white, terracotta, dark green and light green
Acrylic paints in crimson, raw sienna and raw umber
Pencil
Matt acrylic varnish
Palette
Decorator's brush, 5cm (2in) wide
Artist's brushes, sizes 5 and 8
Fitch brush
Varnishing brush, 5cm (2in) wide

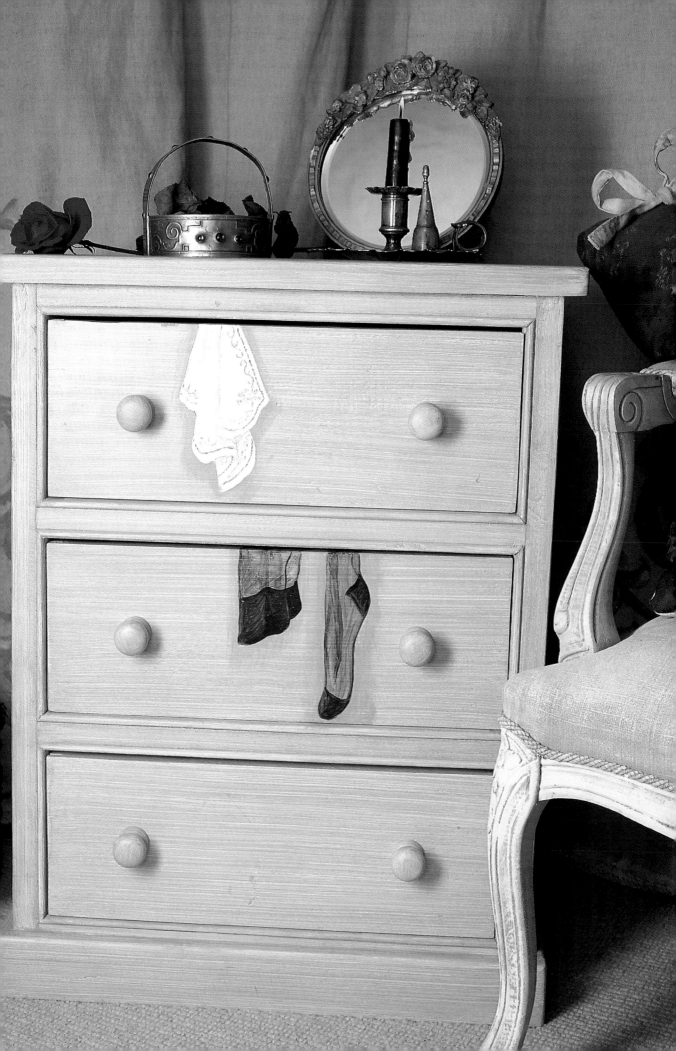

1 Apply acrylic undercoat primer over the whole chest. When dry, cover it with a mixture of one part tan emulsion (latex) and three parts scumble glaze, using the decorator's brush to give a heavy dragged finish (see page 10).

2 Make templates (see page 140) for the trompe l'oeil items and draw around them on the chest. Now paint shadows around the outsides of the outlines using the no. 8 artist's brush and undiluted tan emulsion. Soften the outer edges of the shadows with the brush dipped in a little water, but leave the inner edges (bordering the outlines) hard.

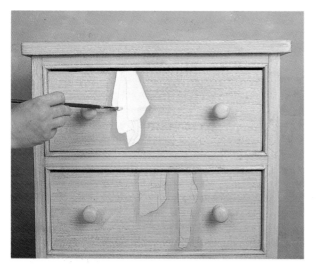

3 Block in the handkerchief but not the black stocking with white emulsion (latex), using the no. 8 brush around the outline and the fitch brush for the centre. By thinning the white slightly with a little water, you can vary the density of the paint so that the form of each item begins to appear. After the paint is dry, lightly pencil in lines for folds and other details within the outline.

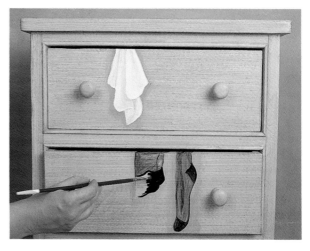

4 As the background colour would show through a sheer stocking, the black stocking is done differently. Put some black on your palette and a little water on the no. 8 brush. Paint this wash over the whole stocking, then use a less diluted black to make a streak representing a fold in the stocking. Use an even thicker black mixture to paint in the toe and heel and the top of the stocking. With the no. 5 brush, paint in a thin line for the seam.

5 Put some white on the palette and add a little black to make a light grey. Add a small amount of water to make it a flowing consistency. With the no. 8 brush, paint in light grey shadows in the folds of the handkerchief. Pick up a little white on the brush, and use this to soften the edges of the shadows while the paint is still wet.

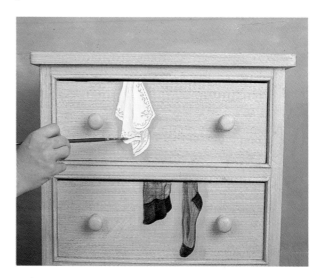

6 Mix a little more black into the light grey you used for the shadows. With the no. 5 brush, paint in the embroidered motif on the handkerchief, using small brushstrokes, like dashes, to simulate the stitches. Make the grey stitching darker in the shadowy areas and lighter on the tops of the folds.

7 Block in the objects on the top of the chest of drawers in the same way as for the handkerchief.

8 Now fill in the colours of the items on the top of the chest using the no. 8 brush, with the no. 5 brush for fine detail. For the pewter plate and silver-backed mirror, mix up some dark grey on your palette and use this to block them in. On the plate, use circular brushstrokes following the outline. Now pick up a little black on your brush, and use this to paint shadowy areas on the plate and an embossed design on the back of the mirror. Do this freehand with the no. 5 brush, and don't make it too detailed or heavy – you can always add more.

9 Block in the envelope in terracotta, then add a little raw umber to the terracotta and shade the edges of the envelope flaps.

10 For the rose, block in the leaves with dark green. Now pick up a little terracotta on the brush you used for the dark green, and paint the stem and thorns. Mix crimson with a little black on the palette, and paint the rose head.

11 Use black mixed with a little raw umber to block in the edges of the diary pages with long, thin brushstrokes. Add more raw umber to the mix, and block in the cover of the diary.

12 Begin adding the midtones and then the highlights, gradually building up the detail on each item. Once again, use the no. 8 brush most of the time, with the no. 5 brush for fine detail. For the pewter plate and silver-backed mirror, use light grey, then paint on tiny highlights of white to give a shine.

13 The envelope is highlighted with terracotta mixed with white, and a white edge is added where it is supposed to have been torn.

14 Add some crimson to the rose flower (not mixed with black this time). Mix light green and dark green, and use this for the leaves' midtones.

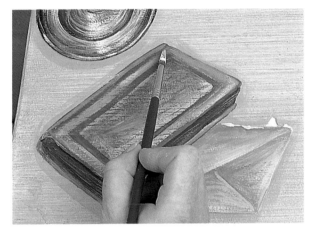

15 Paint raw sienna onto the diary's spine, pages and cover, leaving a dark rectangular border on the cover. Add some white to the raw sienna and use this to lightly highlight the diary.

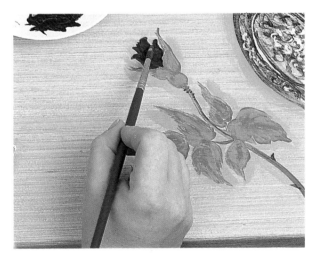

16 Mix a tiny bit of white into the crimson (not so much that it looks pink) and highlight the edges of the rosebud petals. With a little light green, highlight the leaves. When everything is dry – allow an hour to be safe – varnish the whole chest of drawers using the varnishing brush.

TECHNIQUES AT A GLANCE

Painting the chest of drawers motifs

ROSE

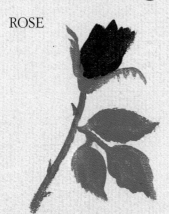

• Block in the colour of the rose. Add terracotta to the dark green and paint the stem and thorns.

• Use crimson for the midtones of the rose flower, and a mixture of light and dark green for those of the leaves.

• Add a little white to the crimson and use this to highlight the rose flower. Highlight the leaves with light green.

MIRROR

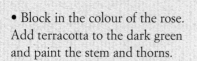

• Block in the mirror back with dark grey, adding black detailing.

• Add light grey midtones to suggest the patterning.

• Highlight the mirror back with a little white.

ENVELOPE

• Block in the envelope with terracotta, adding a little raw umber to the edges of the flaps.

• Mix white with the terracotta to accentuate the flaps.

• Add more white to the terracotta to highlight the flaps further. Use pure white for the torn top edge.

STOCKING

• Paint the stocking in a watery black wash.

• With a less diluted black, add a fold. Use an even thicker black for the stocking top, toe and heel.

• Paint in a fine black line for the seam.

PEWTER PLATE

• Block in the pewter plate using circular brushstrokes and dark grey. Pick up a little black and use to create shadowy areas.

• Add light grey midtones to the plate.

• Highlight the plate with a small amount of white.

HANDKERCHIEF

• Create light grey shadows in the folds of the handkerchief.

• While the light grey is still wet, soften the edges with a little white.

• Use dark grey for the embroidery, adding a little white for the stitching on the tops of the folds.

DIARY

• Paint in the pages using long, thin brushstrokes and black mixed with raw umber. Add more raw umber to the mixture, and block in the cover.

• Apply midtones of raw sienna to the pages, spine and cover.

• Add a few further highlights to the cover using raw sienna mixed with white.

BATHROOM CUPBOARD

Use trompe l'oeil to transform an old cupboard into an unusual bathroom cabinet. You can hide all those not-so-attractive bottles behind the door, then paint prettier ones on the front. Before the trompe l'oeil is painted, the cabinet itself is painted and then the transfer metal leaf applied. We used silver leaf because it blends with chrome bathroom taps, and the blues were chosen because they go well with silver. The deep rust and amber complement the blues beautifully. You could obviously change the colours to go with your own decor.

Transfer metal leaf and gold size (the glue used to apply it) are available from art supply shops. This is a good project on which to practise gilding, because a perfect finish is not required – the surface is meant to look rough and time-worn. The trickiest part is deciding when the gold size has reached the 'tack' stage. The average drying time for gold size is about 30–60 minutes. If you haven't applied enough, you can always reapply it. To clean the gold size off the brush when you have finished, use turpentine. Don't pour any leftover size back into the tin.

All the trompe l'oeil objects are meant to have reflective surfaces, so the reflected colours of the items are used as highlights to add to the illusion. The position of the highlights is determined by the location of the imagined light source; for the cupboard shown here, it is slightly to the right.

The trompe l'oeil techniques used here are covered in detail on page 66 (Bottles), with the techniques for the perfume atomizer spray on pages 51–52 and 55–57 (Cord and Tassels).

YOU WILL NEED
To prepare cupboard:
Acrylic undercoat primer
Vinyl matt emulsion (latex velvet) in indigo, turquoise and emerald green
Gold size
$^1/_2$ book transfer metal leaf such as silver
Sandpaper in medium and fine grades
Decorator's brush, 5cm (2in) wide
Fitch brush
Wooden spoon or spatula
Scrim (mutton cloth)

For trompe l'oeil panel:
Vinyl matt emulsion (latex velvet) or acrylic paint in black and white
Acrylic paints in ultramarine blue, deep rust orange, raw umber and raw sienna
Watercolour pencil in blue or black
Palette
Fitch brush
Artist's brushes, sizes 5 and 8
To finish panel:
Matt acrylic varnish
Varnishing brush, 5cm (2in) wide

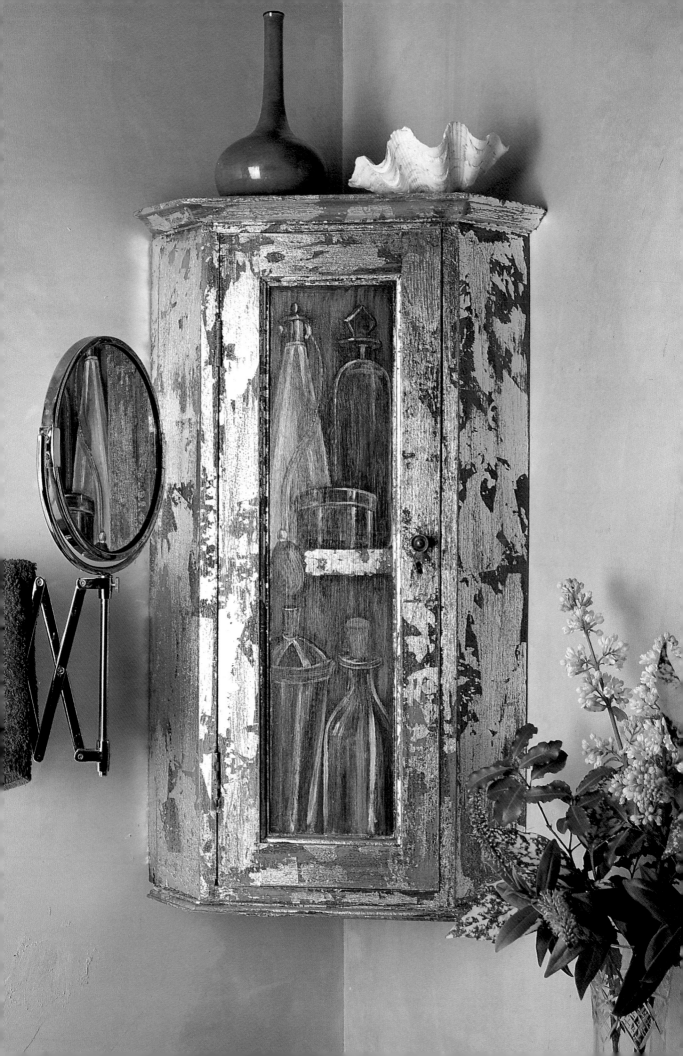

1 Sand down the cupboard with medium-grade sandpaper, then apply the acrylic undercoat primer all over the cupboard, including the door panel, using the decorator's brush. Still using the decorator's brush, apply patches of the three emulsion (latex) base coat colours straight from the can, following the grain of the wood. Do this quite roughly, so that the colours showing through the silver in the end will be varied. Do not paint the door panel with it, however. Allow to dry thoroughly, which could take two or three hours.

2 Using the watercolour pencil, draw your composition on the door panel. The viewpoint is at eye level, so use the same perspective techniques as for the middle shelf on pages 58–61.

3 Decant a little gold size into a clean jar. Using the fitch brush, apply the gold size over the cupboard, except for the door panel. Do not cover the cupboard completely with it – you won't want the leaf to stick everywhere, as it is supposed to look patchy. Allow the size to dry for the specified time – perhaps 30 minutes to an hour – until it reaches the 'tack' stage.

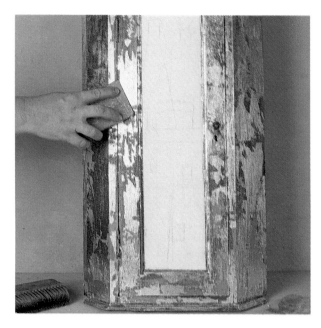

5 If the metal leaf is too heavy in places, lightly rub some of it off using fine sandpaper. If there is not enough in other places, apply more size, leave until tacky and then apply some more leaf. Allow to dry for a full 24 hours.

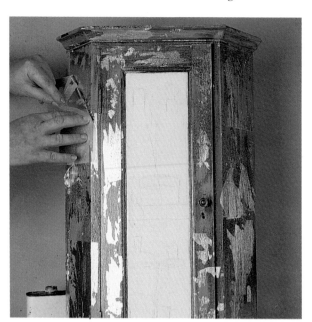

4 When the gold size feels tacky, it's time to apply the leaf. Press one square at a time onto the gold size, being careful not to move it once it is in contact with the size. Rub it with the back of a wooden spoon or spatula and then peel off the backing paper. Apply it all over, since the areas with no size will not be covered. When you have finished, use a piece of scrim (mutton cloth) to dust off any flakes that have not stuck. Save the transfer paper with any remaining bits of silver attached so you can re-use it. The size needs to set for 24 hours.

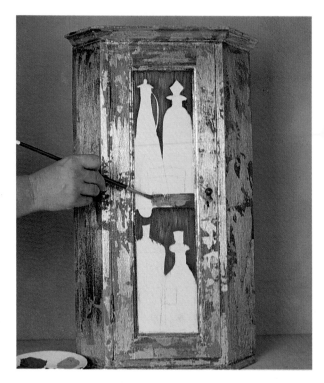

6 Add a little black to the three emulsion colours you used for the base coat. With the fitch brush and the no. 8 artist's brush, paint the background around the outlines of the objects on the door panel using vertical strokes. (Use the fitch to pull the colour out vertically, and the no. 8 brush to outline the objects.) With the no. 8 brush, paint in the same three colours on the front edge of the shelf, using horizontal strokes.

7 Put all the colours you will need for the objects on your palette. Because the surfaces are reflective, you will be using all the colours as you fill in the objects and add the reflections, so that the base coat does not dry out before you've applied them. Mix each colour on the palette with a little water, to give a fluid mix.

8 Now block in each object using the no. 8 artist's brush. Use white and turquoise for the perfume bottle and black for its atomizer. Mix black with ultramarine blue for the bottle with the glass stopper, blending it with the other diluted colours. If necessary, dip the brush in water to keep the paint easy to blend. Use black and white for the small chrome pot and the tall chrome jar, adding reflections using the various colours on the palette. For the bottle with the cork, combine black and white with the mixture of the three base colours, and use this to fill in the shape, then mix deep rust orange with water and use for the liquid. For the cork, use raw umber mixed with raw sienna.

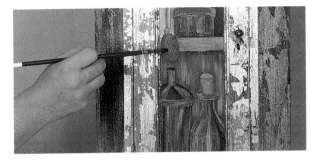

10 With the no. 5 brush, paint in the details on the cork and the perfume bottle atomizer spray using raw sienna.

11 Add some white to each colour, and paint the midtone details using the no. 5 brush. Neaten any rough edges of the background using the same brush and the three base colours.

12 Using the fitch brush, lightly paint gold size on the shelf edge as in step 3. Leave it until it is tacky, then apply transfer leaf to it as in steps 4–5.

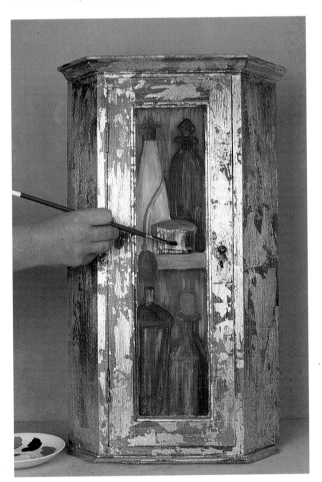

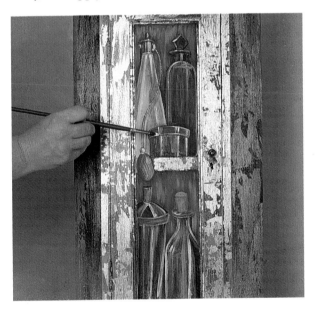

13 Applying large, soft highlights and small, bright highlights will add to the reflective quality of the surfaces. For the perfume bottle, add white to the diluted base colours and apply with the no. 5 brush. For the other items, thin some white paint a little and use this to paint the larger highlights, with the no. 5 brush. Now use the tip of the same brush to paint small beads of undiluted white on all the objects, taking into account the direction of the light. Mix white with raw sienna, and stipple (dab) this onto the cork to create the cork texture.

9 Add more paint to those on your palette so they are all less runny. With the no. 5 brush, add reflective patches to each object. Shown here is the small chrome pot with a turquoise reflection being added.

14 When everything is dry, apply a coat of matt varnish to the door panel, except for the shelf.

TECHNIQUES AT A GLANCE

Painting the bathroom cupboard

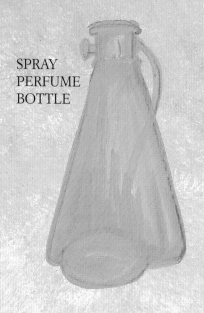

SPRAY
PERFUME
BOTTLE

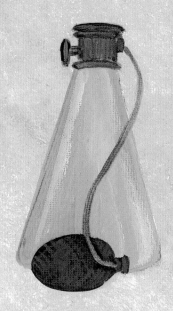

• Mix white and turquoise paint with a little water, and block in the colours, blending the edges together.

• Add white to the diluted base colours and apply the midtones to the glass. Fill in the atomizer spray with black and then use raw sienna for the midtones.

• Add more white to the diluted base colours, and use this for large, soft highlights. Add tiny, bright highlights with undiluted white.

SMALL CHROME POT

• Block in the base colour using black and white mixed in varying proportions.

• Add reflections using the colours of the adjacent objects.

• Create large, soft highlights with diluted white, then add tiny, bright highlights with undiluted white.

BOTTLE
WITH
GLASS
STOPPER

• Mix black with ultramarine and block in the base colour, blending it with the thinned colours.

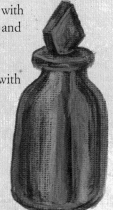

• Add white to the base colour, and paint the midtones. Add reflections using the colours of the adjacent objects.

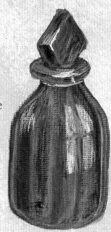

• Create large, soft highlights with diluted white, then add tiny highlights with undiluted white.

TALL CHROME JAR

• Block in the base colour using black and white mixed in varying proportions.

• Add white to the base colour, and paint the midtones. Add reflections using the colours of the adjacent objects in the cupboard.

• Create large, soft highlights with diluted white, using long brushstrokes, then add tiny, bright highlights with undiluted white.

BOTTLE WITH CORK

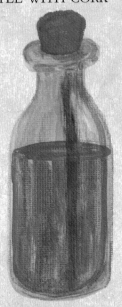

• Mix black, white and the base colours, and fill in the shape. Block in the cork with a mix of raw umber and raw sienna. Paint the liquid with a deep amber wash.

• Add white to the base colour, and paint the midtones very sparingly, as this is transparent glass.

• Create large, soft highlights with diluted white, then add tiny, bright highlights with undiluted white. Add white to raw sienna, and stipple onto the cork.

BASE CUPBOARD AND PANEL

On the cupboard, apply an undiluted, thick coat of each of the three emulsions along the grain of the wood. Add a little black to each and paint the panel background around the outlines.

TOY CUPBOARD

A ny young child will adore a colourful and fun toy cupboard in which the toys painted on the front are as jolly as the ones inside. The project can be adapted to suit virtually any cupboard. This one utilizes the four panels on a full-sized door, but a door without any panels would be suitable too, or you could paint a small cupboard or chest of drawers. Just choose the designs you and the child you are making it for like best – or that you feel confident about drawing.

Children love objects they can easily identify, so you might wish to use the techniques shown here to paint a favourite teddy or other toy. The little mouse is always a winner. He could peek out from behind a book or from inside a sock if you don't want to paint the whole body. The musical instrument could be copied from a toy one the child plays, or it could be a fantasy one that doesn't exist at all.

You could also personalize the books by giving them titles including the child's name along with those of his or her friends and family. For the lettering on the books and on the box, remember to use lower-case letters, not capitals, for a very young child. The letters could relate to objects in the other pictures, such as 't' for teddy. Bright colours always appeal to children, but you don't have to use all the colours shown here. If you prefer, just use the primary colours, or some of the colours you already have from other projects.

The skipping rope (jump rope) uses techniques similar to those used for the cord and fringing on pages 51–57, while the techniques used for the fabric are similar to those used for the fabric on pages 50–54. For the books see the techniques used for books on pages 64–65.

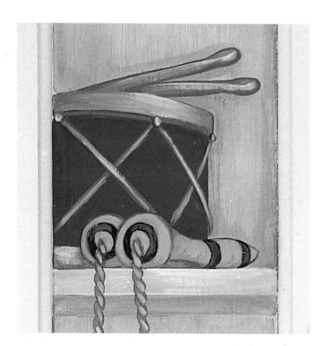

YOU WILL NEED
Acrylic undercoat primer
Vinyl matt emulsion (latex velvet) in dark beige,
 cream, white and black
Acrylic paints in scarlet red, emerald green, cobalt
 blue, violet, cadmium yellow and raw umber
Watercolour pencil
Sandpaper
Matt acrylic varnish
Palette
Decorator's brush, 5cm (2in) wide
Artist's brushes, sizes 5 and 8
Fitch brush
Varnishing brush, 5cm (2in) wide

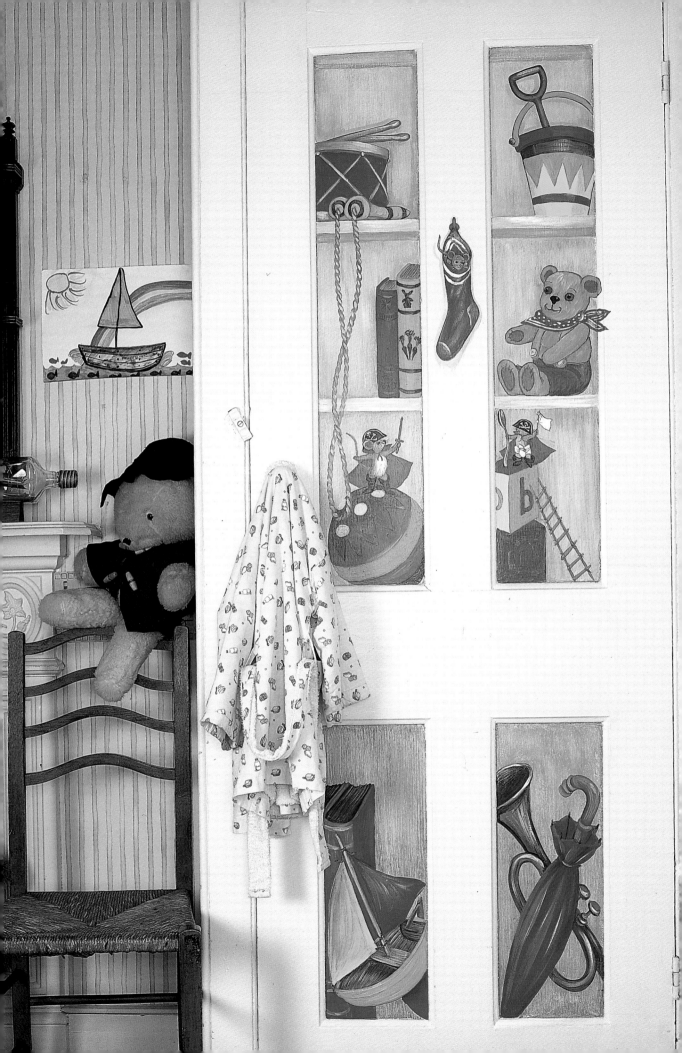

1 Sand the door panels lightly, then apply an acrylic undercoat using the decorator's brush. Sketch your design lightly onto the panels, using the watercolour pencil. Paint in the shadows around the objects using dark beige emulsion (latex) and the no. 8 brush. With the fitch, paint the background beyond the shadows in cream emulsion, using vertical brushstrokes. Dip the brush in water occasionally to make the paint easier to apply.

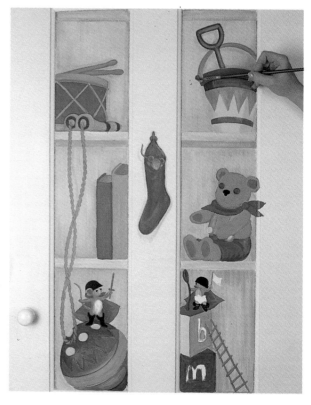

3 Mix white or cream with each colour in turn and paint in the midtones on all the objects, using the no. 8 brush. The objects should be paler where it appears that the light hits them. Once again, paint everything in a particular colour at one time.

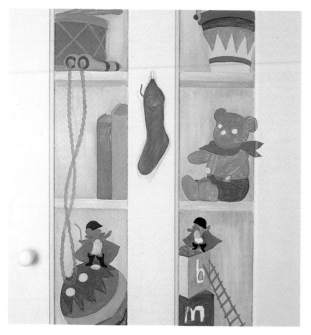

2 Using the no. 8 brush, block in all the colours of the objects and toys, working on all the subjects in a particular colour (including those on the lower panels – see step 6) at one time so that you can judge the colour balance as you go.

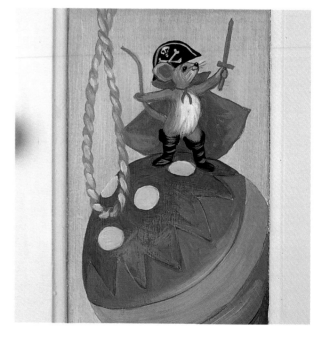

4 Using the no. 5 brush, add the details to the objects and toys – for example, the mouse's hat and scarf, the spots on the teddy's bandana and the eyes of the animals.

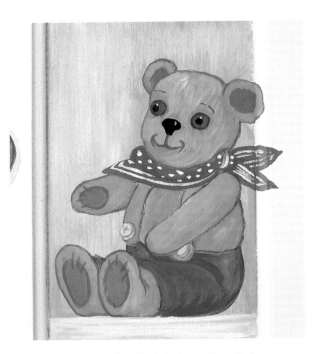

5 Using the no. 5 brush, lightly outline all the animals with raw umber, to define their shape. Take up some white on the tip of the brush, and put tiny dots into the eyes and on the noses of the animals.

6 The bottom panels are painted at the same time as the upper panels, first blocking in the colours, then adding midtones, details and outlines, and finally highlighting in the same way.

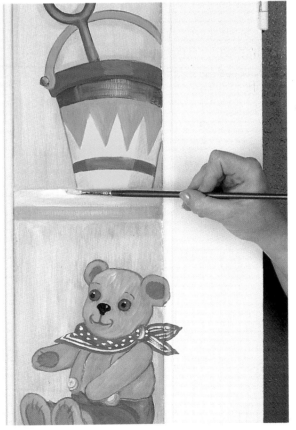

7 Using the no. 5 brush, touch up the horizontal shelf edges with the cream, and tidy up any other rough edges. Add details and titles to the spines of the books, and highlight the drum with cream, using the same brush. Leave for at least an hour, until the paint is completely dry. Varnish to protect your work from sticky fingers. Allow to dry, then apply a second coat of varnish.

TECHNIQUES AT A GLANCE
Painting the toy cupboard motifs

DRUM

• Block in the base colours.

• Add cream to the base colours, and apply the midtones.

• Use cream for the lightest highlights, and outline the drum with raw umber.

SKIPPING ROPE (JUMP ROPE)

 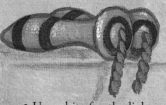

• Block in the base colours of the handles and rope.

• Add white to the base colours, and apply the midtones.

• Use white for the lightest highlights. Outline the handles with raw umber. The rope does not need an outline.

BLOCKS

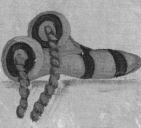

• Draw the blocks. Here they are a little below eye level, so the perspective should be as for the bottom shelf on pages 58–61. Block in the colours.

• Add white or cream to the base colours and paint in the midtones. The viewpoint here is looking up at the blocks, as for the top shelf on pages 58–61.

• Paint in the letters. The blocks shown here are at eye level, as for the middle shelf on pages 58–61.

MUSICAL INSTRUMENT

• Block in the base colours using a mixture of dark beige and black emulsion (latex).

• Mix cream with the dark beige, and apply the midtones.

• Add light highlights of cream mixed with dark beige, and a small cream highlight.

TEDDY

• Block in the base colours. (You can dress the teddy in whatever outfit you wish – the painting technique will remain the same.)

• Mix the colours with white and add midtones. Use black for the centres of the eyes and for his nose, and raw umber for the other facial details and outline.

• Outline the body with raw umber. Add buttons with yellow and white, and outline the detail with raw umber. Paint the eye and nose highlights in white.

SAILBOAT

• Block in the base colours.

• Add white to the colours, and highlight the inside of the boat, hull and sails.

• Define the shape with a light outline of raw umber.

MOUSE

• Block in the base colours.

• Mix the colours with white or cream, and add the midtones.

• Add the hat details and white highlights on the eyes, boots and chest. Add the nappy (diaper). Outline in raw umber.

FIRESCREEN

A firescreen is an ideal place for trompe l'oeil. Painted on a piece of board such as chipboard (particleboard) or MDF (medium density fibreboard), it is a good way to cover up an empty fireplace in the summer or the ashes in the winter.

The colours are deliberately kept muted in this project, with the only strong colour being on the pot and the tassels. However, you could use more vivid shades, or colours to match your decor. Other ways to vary the painting include depicting flowers in a large vase and using different objects on either side.

Because the painting is viewed from above, the perspective is worked out in the same way as for the bottom shelf on pages 58–61 and then exaggerated. The techniques used for painting the fabric swag, cord and tassel are explained in detail on pages 50–52 (Plain Fabric Swag and Trimmings). Those used for the books and pot are covered fully on pages 64–65 (Books) and 67 (Vases). The candlestick uses techniques which are similar to those covered on page 66 (Bottles) but with a heavier application of paint.

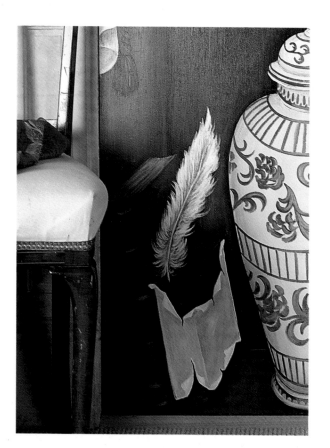

YOU WILL NEED
Board to fit fireplace
Acrylic undercoat primer
Vinyl matt emulsion (latex velvet) in black, dark
 beige, medium beige, cream and white
Acrylic paints in violet, raw umber and raw sienna
Watercolour pencil in black
Palette
Decorator's brush, 5cm (2in) wide
Fitch brush
Artist's brushes, sizes 5 and 8

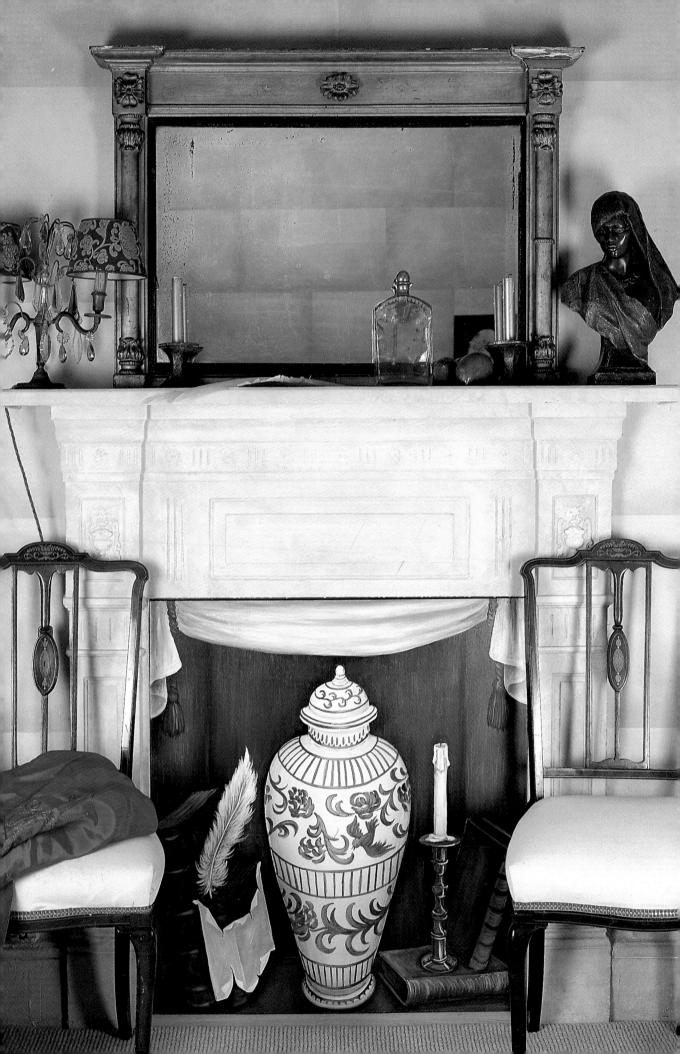

1 To prepare the board for painting, make sure it is smooth and free of dust, then paint it with an acrylic undercoat primer, using the decorator's brush.

2 Sketch out your composition. To make sure that the pot is symmetrical, draw only one half of it, then make a template from this for the other half (see page 140 and also page 20).

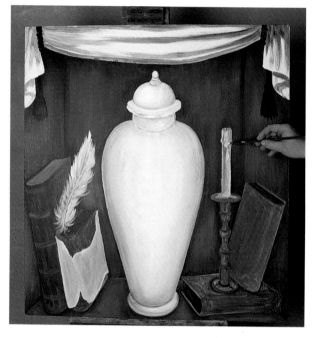

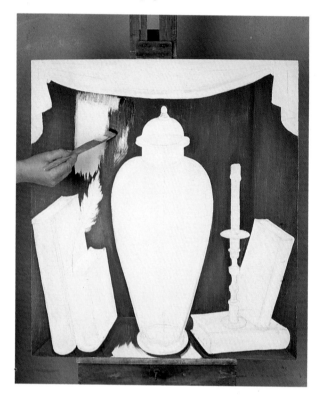

3 Using the decorator's brush and the fitch, paint the background, starting with black around the outline of the objects and fabric, as though they were casting shadows. As you come away from the outlines, add more and more dark beige emulsion (latex) and make the strokes increasingly vertical. Add shadows down the back 'corners' as well.

4 With the no. 8 brush, paint the swag as for the plain swag on pages 50–51 (steps 2–4) using dark beige, medium beige and cream. Using the same brush, paint the cord and tassels with violet as for the cord and tassels on pages 51–52 (steps 5–7).

5 Block in the books using raw umber mixed with raw sienna, and block in the pot using white mixed with a little black (adding extra black for the shadows around the top and base and down one side). Use the fitch for the larger areas, and the no. 8 brush for the rest. Mix the white, dark beige and black together and block in the feather and candle, using the no. 5 brush. Using the no. 8 brush, paint the candle wick in black with a touch of raw sienna.

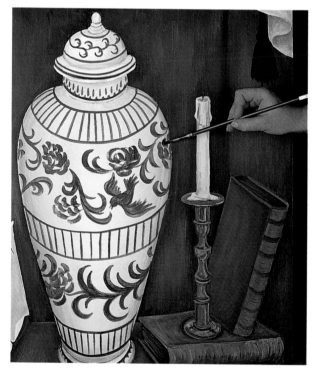

6 With the pencil, lightly sketch the design on the pot then paint it on using the no. 5 brush and violet acrylic paint.

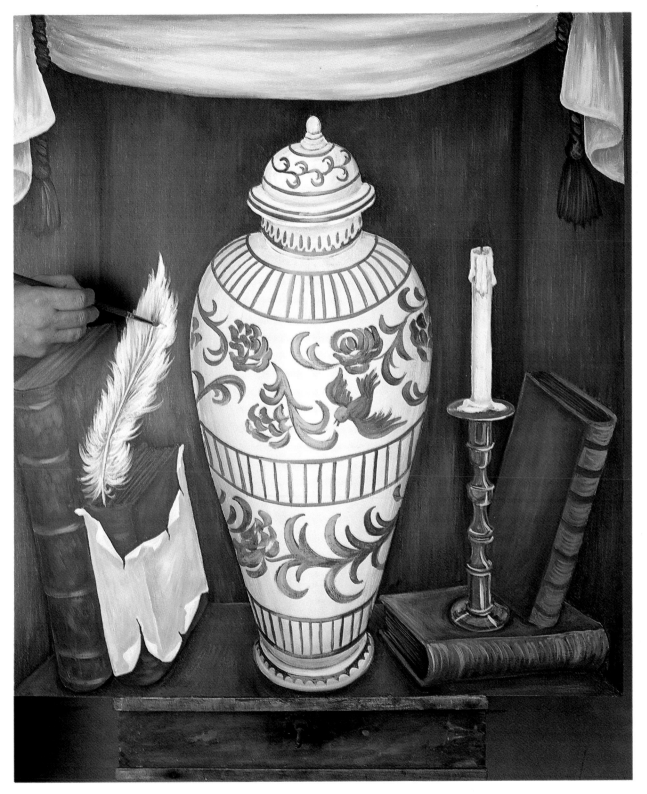

7 Using the no. 8 brush, apply midtones to the book jacket using raw sienna, slowly adding a little white to vary the tones. Add dark beige to the colour used for the feather, and paint the midtones. Add white to the colours for the other objects, and paint the midtones on them.

8 Highlight the book jacket with a mixture of raw umber and white using the no. 8 brush, and the torn edges of the jacket with white using the no. 5 brush. For the other objects, add more white to the midtone colours and lightly paint in highlights using both brushes. Mix water with some white paint and apply this glaze to the pot where the light would hit it, using the no. 8 brush.

Painting the firescreen motifs

FEATHER

• Use a mixture of raw sienna, black and white to paint on the shadows of the feather.

• Add more dark beige to the mixture and paint the midtones.

• Highlight the feather with white.

BOOKS

• Paint the shadows of each book using a mixture of raw sienna, raw umber and black.

• Add raw sienna and a touch of white to the mixture and paint on the midtones. Continue adding white to creater the lighter tones.

• Highlight the book jacket with raw umber and white, and highlight the torn edges of the book jacket with white.

CANDLE

• Use dark beige and black mixed with white to paint in the shadows of the candle wax. Paint the wick in black with a touch of raw sienna.

• Pick up some more white and use this colour to add midtones and soften the shadows.

• Highlight the candle with touches of white.

CANDLESTICK

• Mix up a dark grey from the black and white. Fill in the outline of the candlestick with it. Pick up a little more black and use this for shadows, to accentuate the shape of the candlestick.

• Add some more white to the grey and paint in the midtones. When you are painting the adjacent objects, add little bits of colour 'reflected' from these objects onto the candlestick.

• Highlight the candlestick with little details of white.

KITCHEN CUPBOARD

The trompe l'oeil technique is perfect for cupboard door panels in the kitchen. If your kitchen is small, one panel might be enough, whereas three or four might look better in a large kitchen. You could even use the subject matter to 'label' the contents of the cupboard.

The cupboard shown here has been given a dragged finish (which is covered in detail on page 10), but if your kitchen cupboards are already painted, just sand down·the panel and give it two coats of primer.

The perspective of the shelves assumes that the cupboard is at eye level, so follow the guidelines for the eye-level shelf on page 36. If the cupboard will be at a different height – perhaps on a base unit – you could alter the perspective as explained on pages 58–61.

The techniques for painting the earthenware jar and stopper, Shaker boxes, oil can, plate and jug (pitcher) are described in more detail in the section on pages 66–68.

The fruit is painted first in monochrome and then a succession of glazes is applied. Only three glazes have been used in the photograph, but the more you apply, the more realistic the fruit will look. The Dutch Old Masters used to glaze the fruit in their still lifes 20 or 30 times. It is essential to use acrylics for this, as emulsion (latex) paints are too opaque and will not allow you to achieve the right translucency.

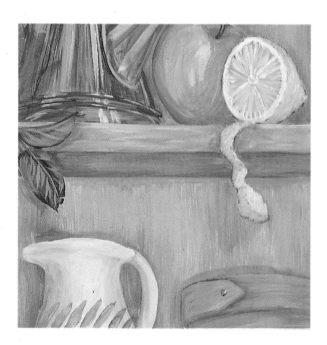

YOU WILL NEED
Acrylic undercoat primer
Vinyl matt emulsion (latex velvet) in blue, black, cream, dark beige, dark green, light green and turquoise
Acrylic paints in raw umber, black, yellow, white, orange and green
Watercolour pencil in grey
Sandpaper
Palette
Matt acrylic varnish
Decorator's brush, 5cm (2in) wide
Fitch brush
Artist's brushes, sizes 5 and 8
Varnishing brush, 5cm (2in) wide

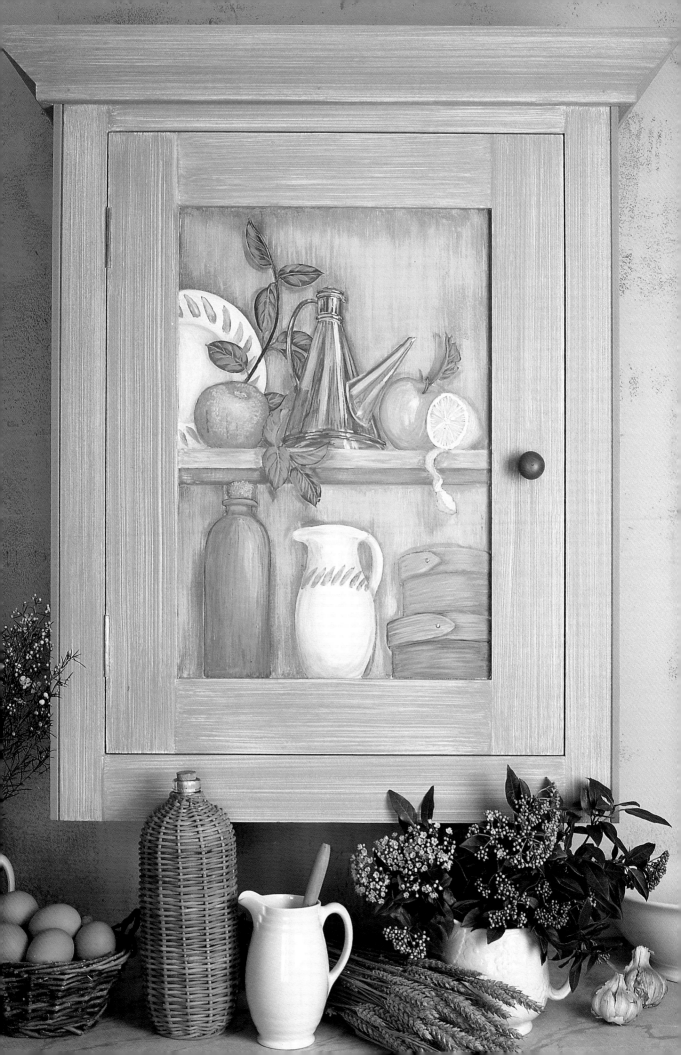

1 Sand down the surface and then paint it with the acrylic undercoat primer, using the decorator's brush. Draw the composition on the inner panel with the watercolour pencil. If you prefer, work it out beforehand on paper, then trace the design using a very soft (6B) pencil. Place the pencilled side against the wall, and draw over the outline with a hard (H) or medium (HB) pencil, pressing quite hard. A faint image will transfer to the wall, and this can then be strengthened with the watercolour pencil.

2 Thin down the blue emulsion (latex) in the ratio of 3 parts paint to 1 part water. Using the fitch, paint this onto the edges of the door and the rest of the cupboard, following the grain of the wood. Now drag the decorator's brush along the wet paint.

3 Mix a little black with the blue and paint the underside of the shelf using horizontal strokes of the no. 8 brush. Soften into the centre with the blue on its own, using the fitch brush, to create the effect of wood. Do not paint the edge of the shelf yet.

4 With the blue-black mixture, use the no. 8 brush to paint shadows on the background around the objects. With the blue on its own, once again soften into the shadows using the fitch brush. Add a little cream to the blue paint, and paint in the background with the fitch brush.

5 Paint the bay leaves and apple leaf in dark green, using the no. 8 brush. With the no. 5 brush, paint the apple stem and the bay leaf stem in raw umber, adding a little green to the colour as you approach the tip of the bay leaf stem.

6 Using the no. 8 brush, block in and then shade each object (excluding the fruit). The colours used for blocking in are turquoise for one Shaker box, dark beige for the other box and for the earthenware bottle, dark beige mixed with white for the cork, black and white mixed to a mid grey for the oil can, and white with just a touch of black for the plate and jug (pitcher). For shading, add a little raw umber or black to each colour.

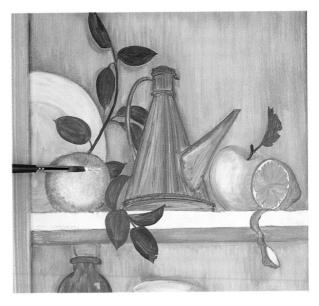

7 For the cut lemon, add some yellow to the raw umber and white, and block in the colour with the no. 8 brush, using the direction of the brushstrokes to indicate the segments. Add a touch more raw umber, and shade the edges. Paint the narrow rim between the fruit and the skin white, to represent the pith. For the apple and the orange, mix a little raw umber with white and use the no. 8 brush to outline the fruits. Add more white to the mix and fill in the centres of the fruits to highlight them, creating a more realistic three-dimensional effect.

8 Mix a little light green emulsion with the dark green, and paint midtones on the leaves using the no. 8 brush. Also add a little white to the colours used for the Shaker boxes and the earthenware bottle, and use these to apply the midtones of these items, again with the no. 8 brush. Mix black and a little white to make a very dark grey, and, still using the same brush, define the edges of the oil can with it.

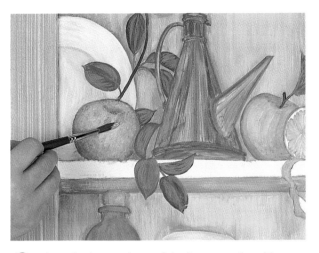

9 When the base colour of the lemon is dry, dilute the yellow acrylic with water on the palette and paint this glaze over the lemon, using the no. 8 brush to build up the colour until it looks like the lemon in this photograph. Use the same glaze to add a yellow reflection to the oil can. Do the same with the orange acrylic for the orange, and the green acrylic for the apple, cleaning the brush between each colour.

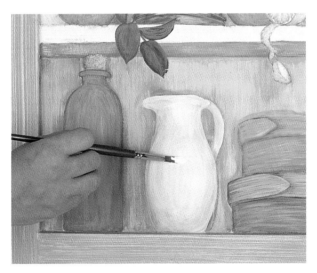

10 When the glaze is dry, repeat the previous step to build up the colour. Mix a little more white with each of the colours used on the Shaker boxes and add highlights to the boxes, using the no. 5 brush. Add some more white to the grey, and use this light grey and the no. 8 brush to add midtones to the oil can. Using white and the no. 8 brush, highlight the jug and the plate, softening the edges into the grey.

11 Pick up some white with the no. 5 brush, then pick up a little raw umber and paint in the pith and segment lines of the lemon; add more white to vary the tones of the pith. Clean the brush, then use a little pure raw umber to paint the orange cap and Shaker box pins.

12 Using the no. 8 brush, add white highlights for the shine on the oil can. Paint white highlights onto the fruit with the same brush, softening the edges onto the glazes. Add white to the dark beige and use this to highlight the earthenware bottle.

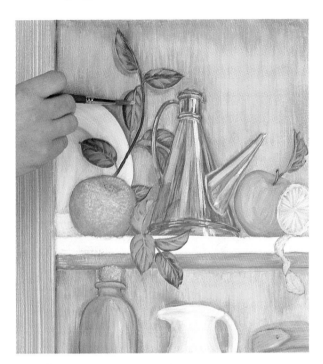

13 With the no. 8 brush, apply a third glaze to the fruit to soften the white highlights. Mix a little dark beige emulsion with white, and use this for the orange cap detail and the midtones of the pins on the boxes, applying it with the no. 5 brush. Mix light green with white and use the no. 5 brush to paint this onto the bay leaves and apple leaf as highlights.

14 Using the no. 5 brush, highlight the pins of the Shaker boxes and the lemon pith and flesh with white. With the same brush, add smaller white highlights to all three fruits, softening the edges. Continue glazing and highlighting if you wish.

15 With the no. 8 brush and the blue emulsion, paint the shelf edge, adding a little black to the blue to create shadows where leaves or the lemon hang over the edge. With the same brush and paint, and using the shape of the brush head rather like a stamp, add a simple pattern to the jug and plate. Mix white with blue and use this and the no. 5 brush to highlight the shelf edge. Strengthen and neaten the background around the objects.

16 When the paint is dry (after about an hour), apply two coats of varnish using the varnishing brush, allowing it to dry between coats (1–2 hours).

Painting the kitchen cupboard motifs

ORANGE

• Paint the orange in monochrome using raw umber and white, adding a little extra raw umber around the edges of the orange.

• Glaze it with an orange wash.

• Add another glaze and then white highlights.

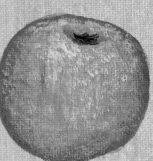
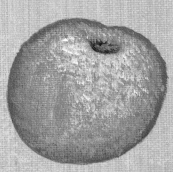

• Glaze the orange a third time, and paint in the cap with raw umber.

• Add smaller white highlights to the orange. Mix dark beige emulsion with white, and highlight the cap.

APPLE

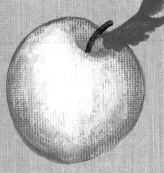

• Paint the apple in monochrome using raw umber and white, adding a little extra raw umber around the edges. Paint the leaf in dark green and the stem in raw umber.

• Glaze the apple with a thin green wash.

• Add another green glaze, followed by white highlights.

• Glaze the apple a third time. If you wish, add a blush of rust. Add midtones to the leaf and stem using dark green mixed with light green.

• Highlight the apple a little with white, softening the edges. Highlight the leaf with light green mixed with white.

LEMON

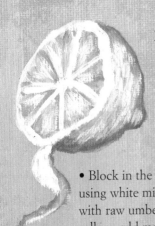
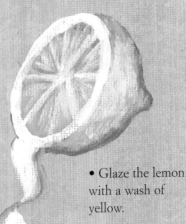

- Block in the lemon using white mixed with raw umber and yellow; add more raw umber for the edges. Paint the pith white.

- Glaze the lemon with a wash of yellow.

- Add another yellow glaze, followed by white highlights. Paint the pith using white mixed with raw umber.

BOXES

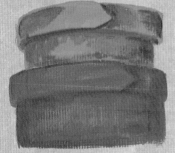
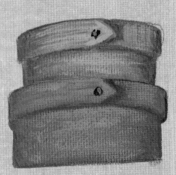

- Block in the colours using turquoise or dark beige emulsion (latex). Add some raw umber to each colour, and use this to shade the edges.

- Add a little white to each colour, and apply as midtones. Paint the pins with raw umber.

- Add more white to each colour and apply as highlights. Apply midtones to the pins using dark beige mixed with white, followed by white highlights.

OIL CAN

- Block in the shape in a mid grey made by mixing white with black. Add a touch of black, and paint in dark shadows.

- Add more black to the grey and use this to define the shape. The coloured reflections are added when the objects that would produce the reflections are painted.

- Apply midtone details using light grey, then highlight with white.

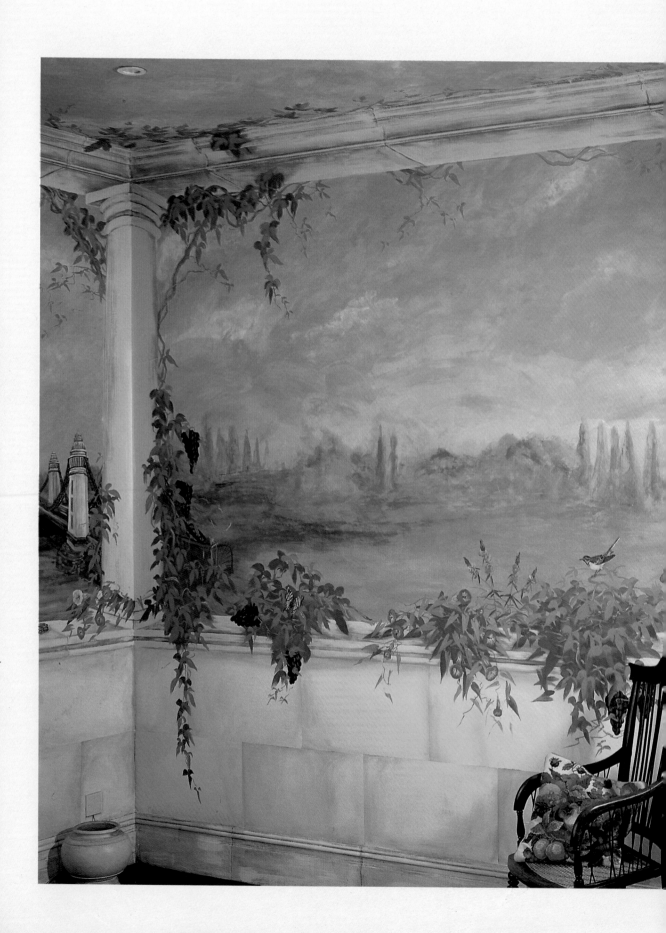

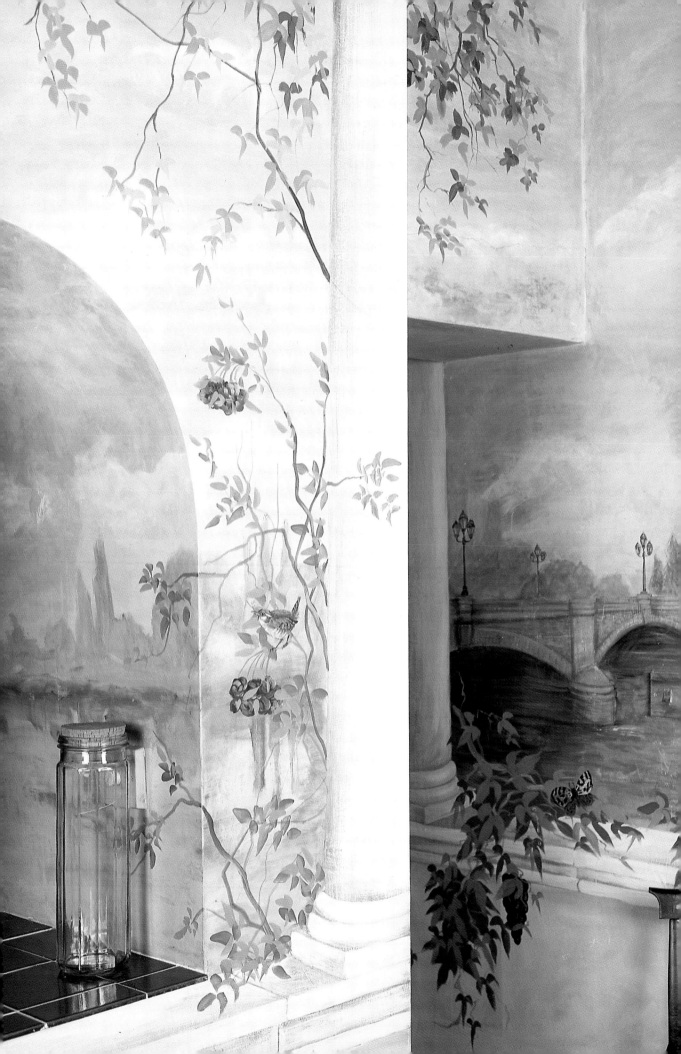

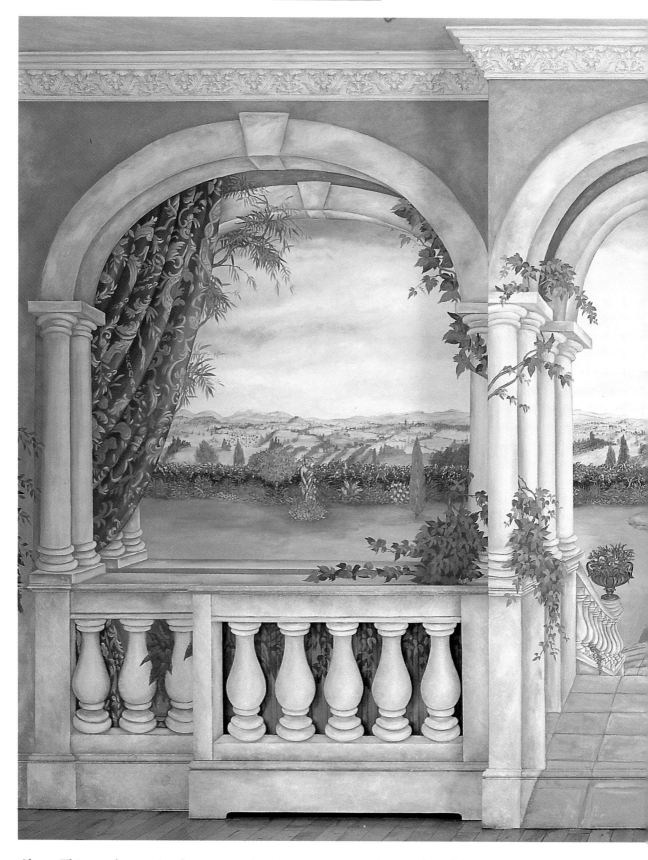

Above: This mural was painted to create a view in a room that didn't have one. The viewpoint is centred on the arch in the middle, which is over a chimneybreast, while the two outer arches have an off-centre perspective. To make them symmetrical, I painted one arch and then traced it and reversed the outline for the other. The same was done for the columns. For the distant background, I applied washes of colour using scrim (mutton cloth) in the same way as for the mural on the previous pages. Unlike that

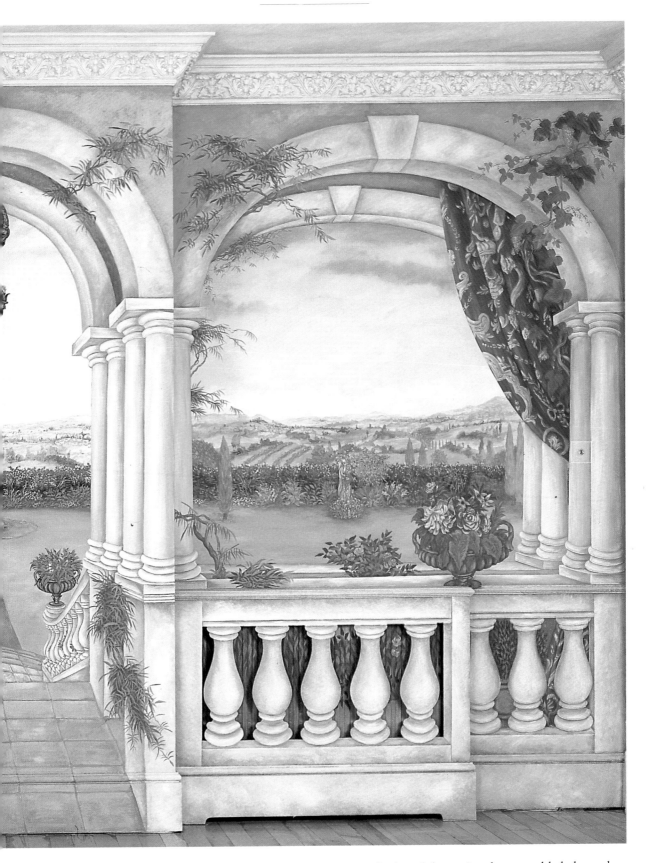

one, however, this mural was painted on canvas. Final details, like the vine trailing onto the top of the door, and the bottoms of the columns and balustrades, were all painted after it was mounted on the wall, in order to get the perspective right. The room's radiators were custom-built and then painted to resemble balustrades. The rest of the room is colourwashed with three tones and embellished with *grisaille* moulding (see page 6). The ceiling is an amber and gold-coloured sky, darkening at the edges to give an illusion of height.

INTERIORS

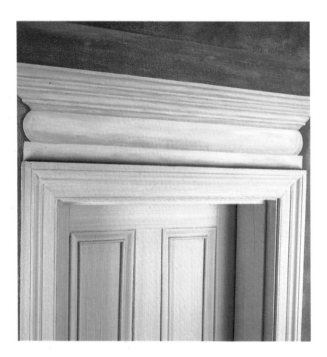

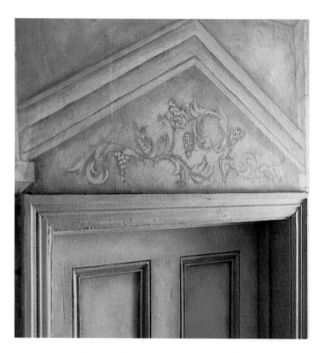

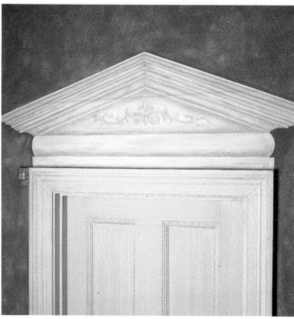

This page: Faux pediments lend grandeur and elegance to a home, creating a classical feel. In rooms that lack architectural features they add interest, particularly when set against a deep colour scheme such as the 'cassis' colourwash shown here. Pediments and doors can be painted in any colour, but I always favour natural, subtle tones of off-white, sand or stone, which set off the other colours used in the room. Doors and pediments in a room do not have to match – different designs and shapes work well together. You could perhaps suggest the uses of the various rooms through the embellishments you choose for the triangular part of the pediment. For example, musical instruments could be used in a music room, or a cornucopia of fruit in a dining room or kitchen.

Opposite: For marbling, blend dark beige, medium beige and cream over the surround using a marine sponge. Mix raw umber with tan and use a fitch to paint in wide, jagged veins like tree roots, blending with the brush. Now draw in lighter jagged lines using an artist's brush, softening with a specialist brush known as a softener.

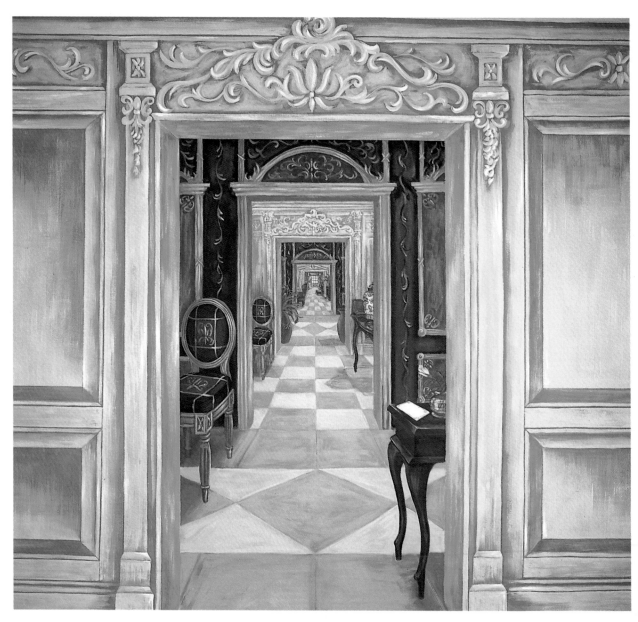

Above: Everybody can have their own 'West Wing'. This impressive vista of rooms was painted on canvas and installed in a hallway. A trompe l'oeil corridor leading to other rooms, and faux doorways with views of imaginary interiors or gardens, can really open out a hall or other room. The techniques, including the perspective and the faux panelling on the surrounding walls, are the same as those covered in this book.

Right: Faux panelling adds character to flat doors such as the fire doors and meter cupboard in this hallway. Faux stonework in the same tones as the doors was used on the walls here.

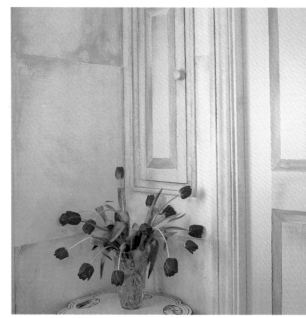

Above: Screens are ideal for trompe l'oeil, partly because they have two sides for you to experiment on. This screen is covered in canvas, on which faux panelling has been painted. Warm honey tones have been used, with dark faux fabric drapes and ornate trimmings (which use the same techniques as on pages 50–52). Other decoration is also possible – you could, for example, paint items of clothing hanging over the screen in the same way as for the stocking on the chest of drawers on pages 90–95.

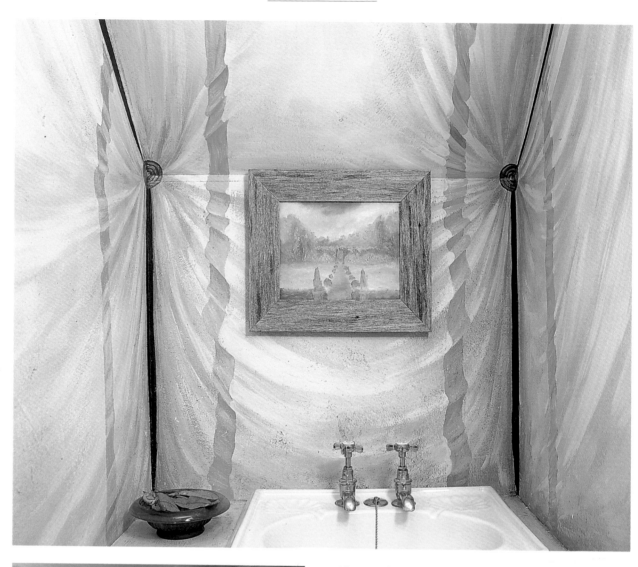

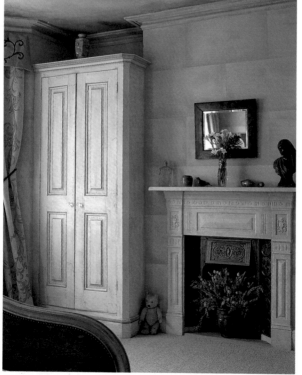

Above: This small cloakroom (powder room) under the stairs provided lots of interesting angles and small areas of wall which were ideal for a trompe l'oeil tented effect. The fabric was painted in the same way as that on pages 50–52, using dark, medium and light tones. I sketched the amber stripes with a watercolour pencil then painted them in so that they followed the folds of the beige fabric.

Left: The walls of this bedroom have been painted with faux stone blocks. The metal fireplace was too dark for the room and so I undercoated it and then painted it with a blend of three tones of emulsion (latex) to produce a pale sandstone. For the grate I lightly applied a mix of gold and bronze acrylic to give a subtle lustre.

Opposite: I based the faux fabric draped over this trompe l'oeil door on a costume designed by the famous turn-of-the-century theatre designer Léon Bakst. The fabric was painted in the same way as that on pages 53–54.

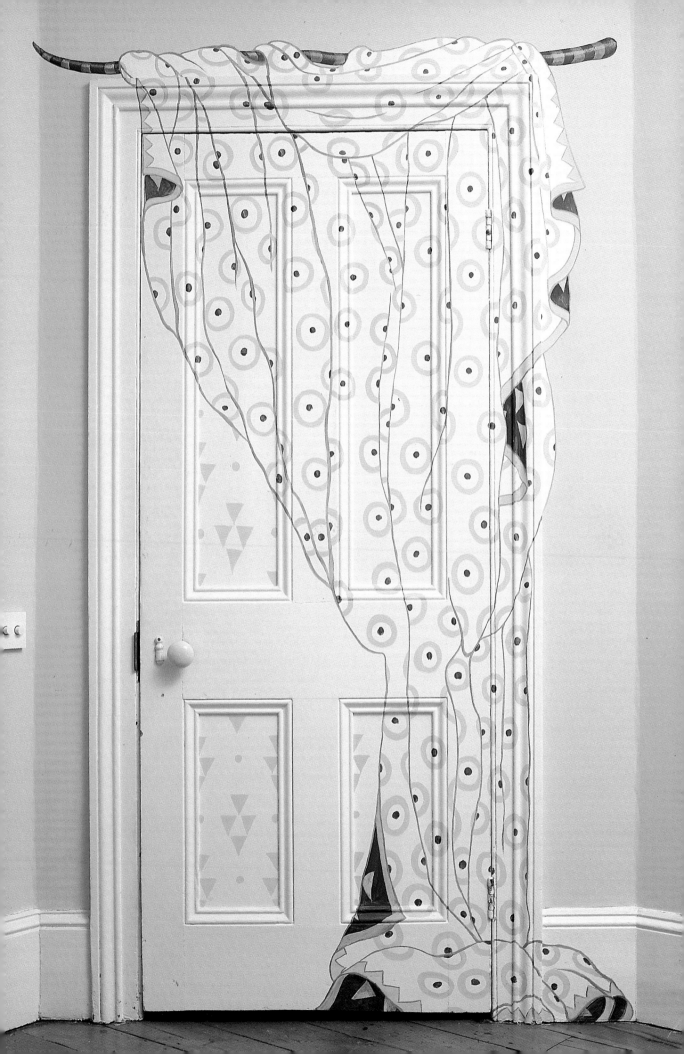

STILL LIFES

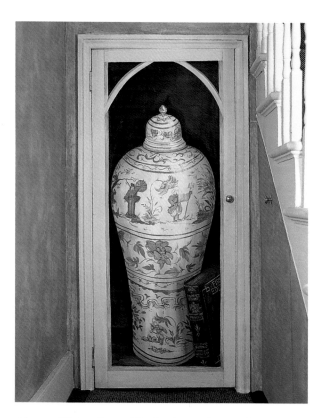

Opposite: This is a wall plaque I have in my own kitchen, and some of the objects it depicts mean a lot to me. It is painted on MDF (medium density fibreboard), using the same techniques as for the three shelves on pages 58–61. How to paint the envelope is covered on pages 93–94, and the herbs on pages 86–89. The methods of painting all the other objects featured are covered in the Techniques part of the book. Note that the ornaments are well spaced so that the shelves are not too cluttered, giving the composition balance and allowing the trompe l'oeil shelves to be seen. The hanging cloth bridges all three shelves, leading the eye through the composition. The lemon peel falling over the edge of the shelf is a device I copied from Dutch Old Master still lifes.

Above: This tall pot fills the door of an understairs cupboard, and the large book is personalized for the owners of the house. The door is flat and so it was possible to paint the wooden surround in the same way as the faux panelling on pages 29–33. The background is black, with a few lighter tones added. Both the background and the pot are painted in the same way as for the firescreen on pages 108–113. This type of pot was often as large as this, and its size – just over a metre (39 inches) high – allowed the pattern to be painted in a lot of detail. For reference, I used photographs of large pots in an auction catalogue, but you might prefer to design your own. It's not as difficult as it sounds, because a lot of the design is simply horizontal bands that separate a wider, freer decorative design.

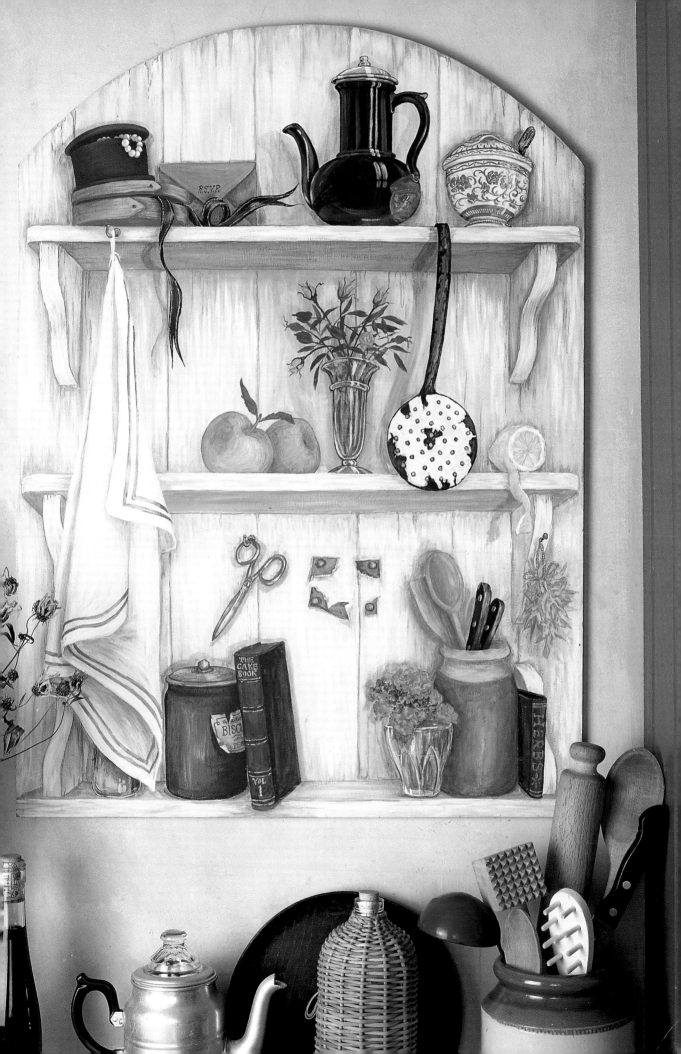

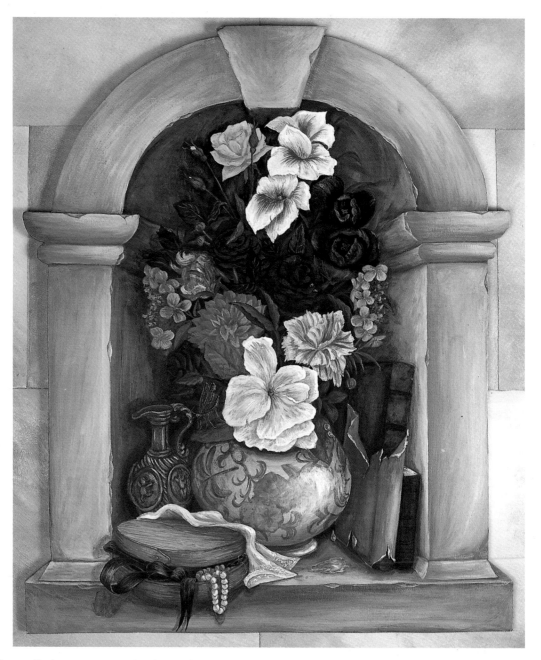

Above: This wall plaque is cut in the shape of a stone niche and can be hung anywhere, or the idea can be extended to larger themes painted straight onto the wall. The board for the plaque is cut to shape with a jigsaw, after the composition is sketched out on a piece of paper. Because the eye level is roughly at the level of the flowers, the perspective for the objects is as for the bottom shelf on pages 58–61. The background and stone arch are painted in dark beige, which is mixed with raw umber for the dark inner area of the niche. I photographed flowers in our garden and used the photos for reference when painting the blooms, adding in new flowers as they came into season. The Shaker box is painted in the same way as the box on pages 114–119, while both vases are painted using the techniques described on page 67.

Opposite: To break up the large expanse of dark green on our kitchen cupboards, I painted trompe l'oeil shelves and objects on the inner panels, once again depicting items that mean something to me. Shown here are the large pantry cupboard doors – the large onion was grown by my father-in-law, and the herbs were grown in my garden. Because there were so many panels to paint, I did them gradually, adding objects when I had the time and filling them as you would an actual cupboard. It's always better to have a few well-painted objects in a still life than to have a large number of badly painted, rushed items. You'll find the techniques for painting all these objects, and the cupboard, in this book.

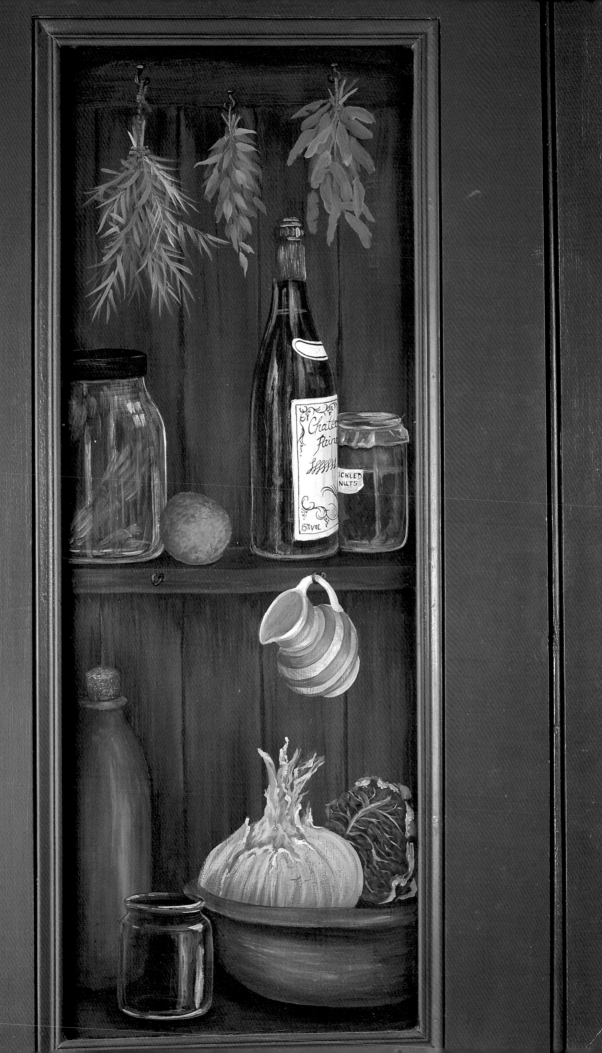

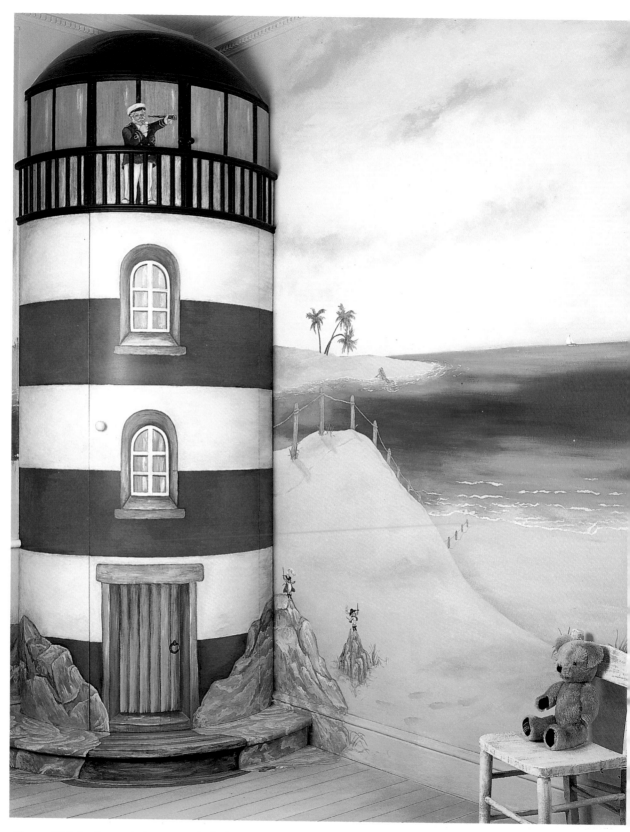

Above: This bedroom belongs to a little boy who loves the sea. The seascape covers the entire room. On the ceiling and cornice I flat-painted a blue sky, adding more and more white as it was taken down to the horizon, and shading in the clouds. I painted the sea a dark blue and aqua green, adding cream to the aqua for the water coming onto the beach. The waves are white squiggles following the shoreline. I painted the beach a sand colour, with white here and there to highlight the dunes. On the lighthouse, which is a cupboard purpose-built in the round, I added a raw umber glaze after the red and white stripes had dried.

CHILDREN'S

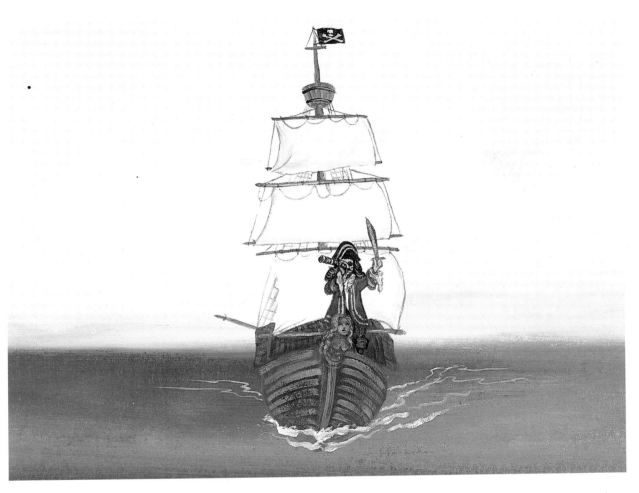

Above: This pirate is the object of intense scrutiny by the lighthouse keeper and mice in the photograph opposite. The boat is painted in the same way as the sailboat in the Toy Cupboard project (see pages 102–107). To get the scale right, I sketched it in watercolour pencil first.

Left: The merry mice relaxing on their raft are pirates too. The method for painting them is shown on page 107 – you can dress them in any outfit that suits the theme. I sketched them on paper first and then transferred the sketch to the wall (see page 140 for instructions). The raft is painted first, next the mice and their clothing, then raw umber outlines and finally the white waves at the edges of the raft and the other white highlights and details such as eyes and the strings of the fiddle.

Above: The floor is painted in two sandy tones to make it look as though the beach extends onto the floor. For the little rock pool shown here, I applied washes of blue, aqua and dark beige, then painted in fish, rocks and a tiny crab. I then added small reflections to create the effect of ripples and splashes. Finally, the floor was sealed with two coats of acrylic floor varnish. This idea works well in a child's bedroom, but it would also be fun for a bathroom.

Right: A plain cupboard in the bedroom was transformed into a wooden beach-house. The wood was first painted in a dirty tan shade over an acrylic undercoat primer. Next I added the shutters, veranda and window and then used brown paper masking tape to paint the straight lines for the weatherboarding. The methods of painting the beach-house, teddy, flowers and foliage are all covered in the Techniques part of the book.

TEMPLATES

Rather than drawing shapes freehand, you may prefer to use a template. That way, you can experiment on paper, where any mistakes are easy to correct. Patterns for some of the designs used in this book are included here, but you can also create your own by tracing a picture. If it is not already the right size, enlarge the pattern or tracing on a photocopier and then cut around it to create your template.

For objects such as pillars and urns where it is important that they are exactly symmetrical, it is best to make a template for only half the object, with a straight edge representing a vertical line down the middle of the object. Draw a vertical line on the wall, tape the template in position with the straight side against the vertical line and draw around it. Now turn the template over, tape it in place on the other side, again against the vertical line, and draw around it.

Even if you are drawing the design freehand

straight onto the wall, it is still advisable to use the above technique for symmetrical objects. Therefore, draw only half the design (ie, one side), then trace it onto tracing paper. Cut it out, turn it over, tape it to the wall, and draw around the outline.

Sometimes a design will contain lines inside the outline, which obviously cannot be transferred simply by drawing around the shape. In these cases, you can transfer the lines by first tracing them using a very soft (6B) pencil, and then turning the tracing over, taping it in position and drawing over the lines with a hard (H) or medium-hard (HB) pencil, pressing firmly. Faint lines will be transferred to the surface, then you can go over them if necessary. Remember that the design will be reversed from the original tracing – if that is a problem, simply go over the lines from the reverse side of the tracing paper using a soft pencil, then transfer *that* to the surface.

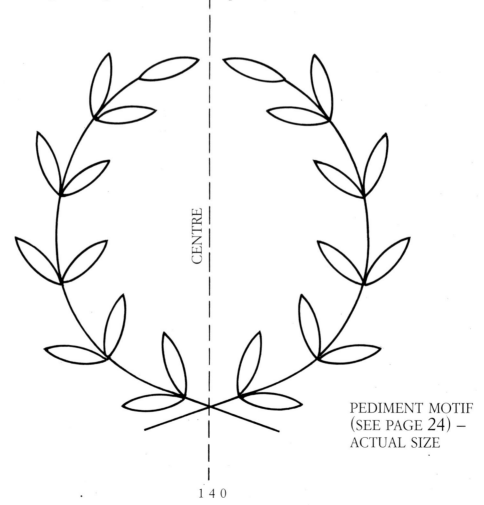

CENTRE

PEDIMENT MOTIF
(SEE PAGE 24) –
ACTUAL SIZE

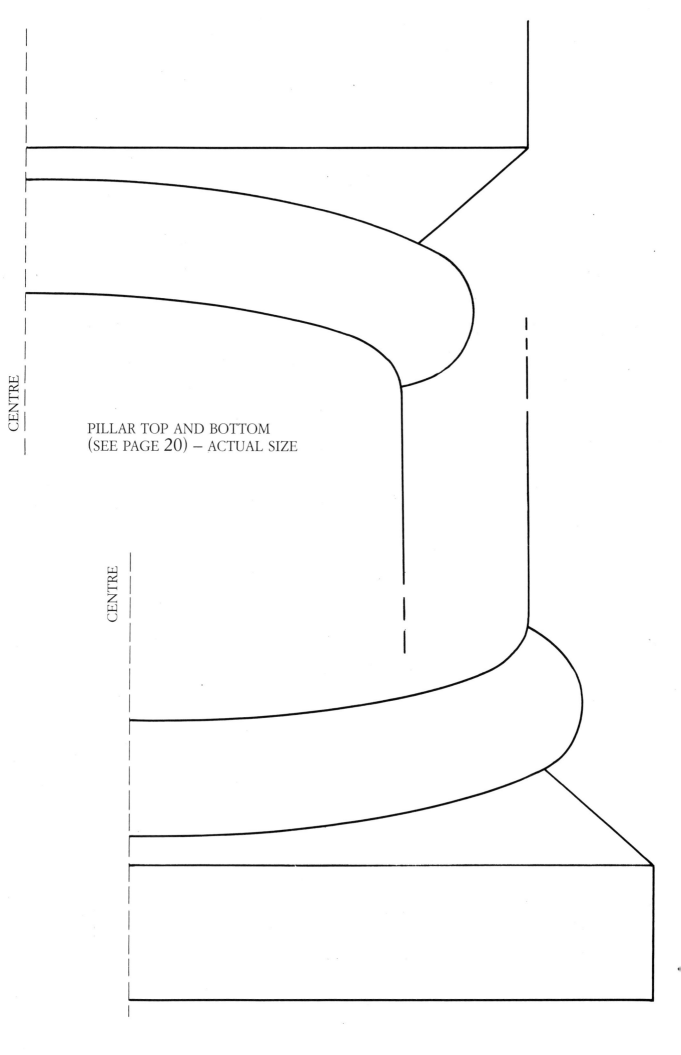

CENTRE

PILLAR TOP AND BOTTOM
(SEE PAGE 20) – ACTUAL SIZE

CENTRE

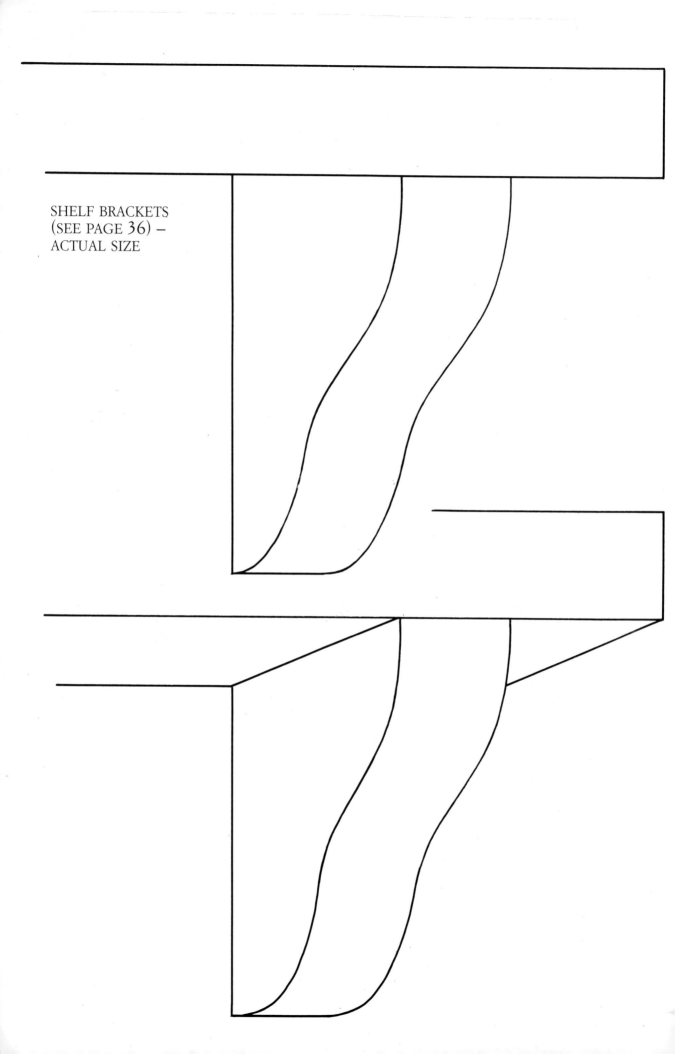

SHELF BRACKETS
(SEE PAGE 36) –
ACTUAL SIZE

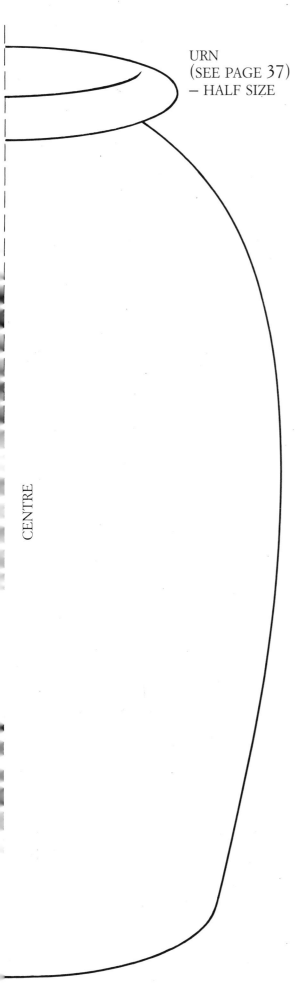

URN
(SEE PAGE 37)
– HALF SIZE

CENTRE

ACKNOWLEDGEMENTS

A special thank you to Arthur Sanderson for supplying all the paints for the book and allowing me to use their fabric for the hat box project. Their range of paint colours is excellent, and their colour cards showing dark to light shades of the same colour are particularly useful. Thanks are also due to Harvey Jones, 57 New Kings Road, London SW6 4SE, for supplying the Shaker-style kitchen cupboard on page 114; Jennifer Taylor of Sophistocat, 192 Wandsworth Bridge Road, London SW6, for supplying the chest of drawers (she sells all types of furniture ready for painting); T.W. Dunn, Fulham Palace Road, London SW6, for all the flowers used in the book. Finally, thanks to all my patrons who allowed me to photograph their commissions.

SUPPLIERS

All the materials used in this book can be easily obtained from local artists' suppliers and do-it-yourself shops. The following shops also offer a mail order service.

Green & Stone
259 Kings Road
London SW3 5ER
(artist's brushes, watercolour pencils and acrylics, gold size and metal leaf, tracing paper, Polyvine water-based varnishes and scumbles)

Papers & Paints Ltd
4 Park Walk
London SW10 OAD
(artist's brushes, fitches, decorator's and varnish brushes, Easymask masking tape, paint kettles, scrim, Sanderson paint, Polyvine water-based varnishes and scumbles, Dulux Trade vinyl matt emulsion, gold size and leaf)

Russell & Chapple Ltd
23 Monmouth St
London WC2H 9DE
(specialist art suppliers of canvas and large paper on a roll cut to length; acrylic paints and primers for canvas; artist's brushes, gold size and leaf)

If you would like to come on a day course or would like to commission some trompe l'oeil work, contact me at Artyfacts, 10 Lysia Street, Fulham, London SW6 6NG, or contact the publishers of this book.

INDEX